Hours of Flowers

A COLORING BOOK FOR ALL

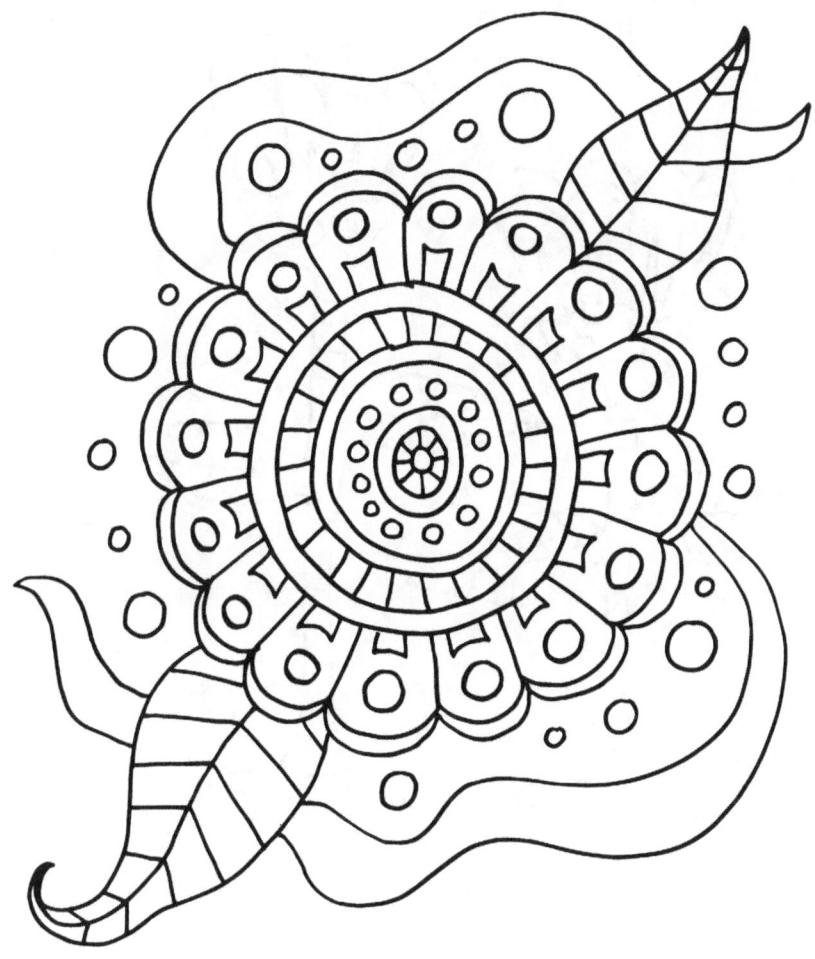

Illustrations by

Kimberly Garvey

Cover Drawing By Kimberly Garvey

Cover Drawing Colored By Donna Pecoraro

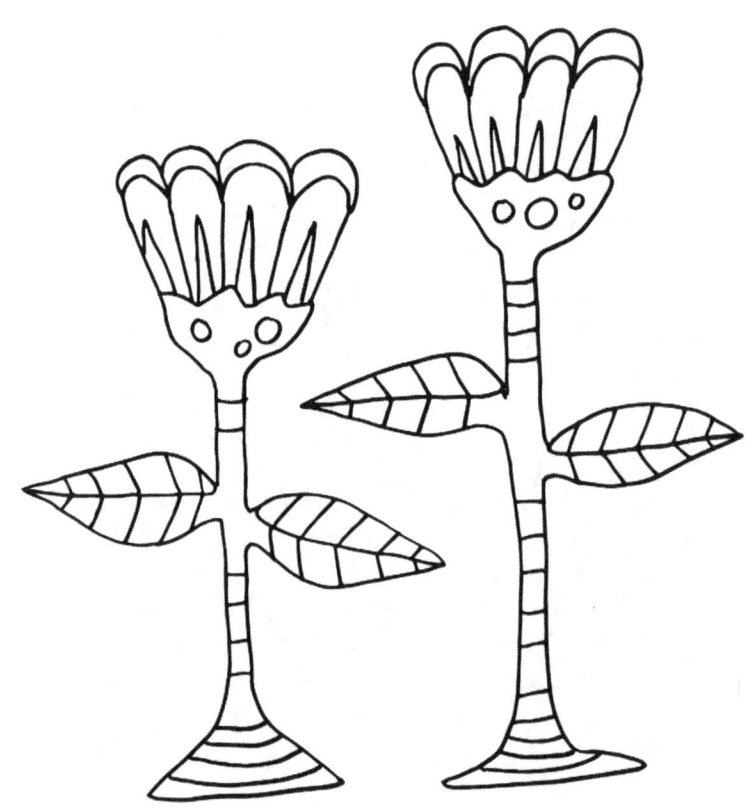

Copyright 2016 by Kimberly Garvey

All Rights Reserved.

No reproduction of any kind without consent.

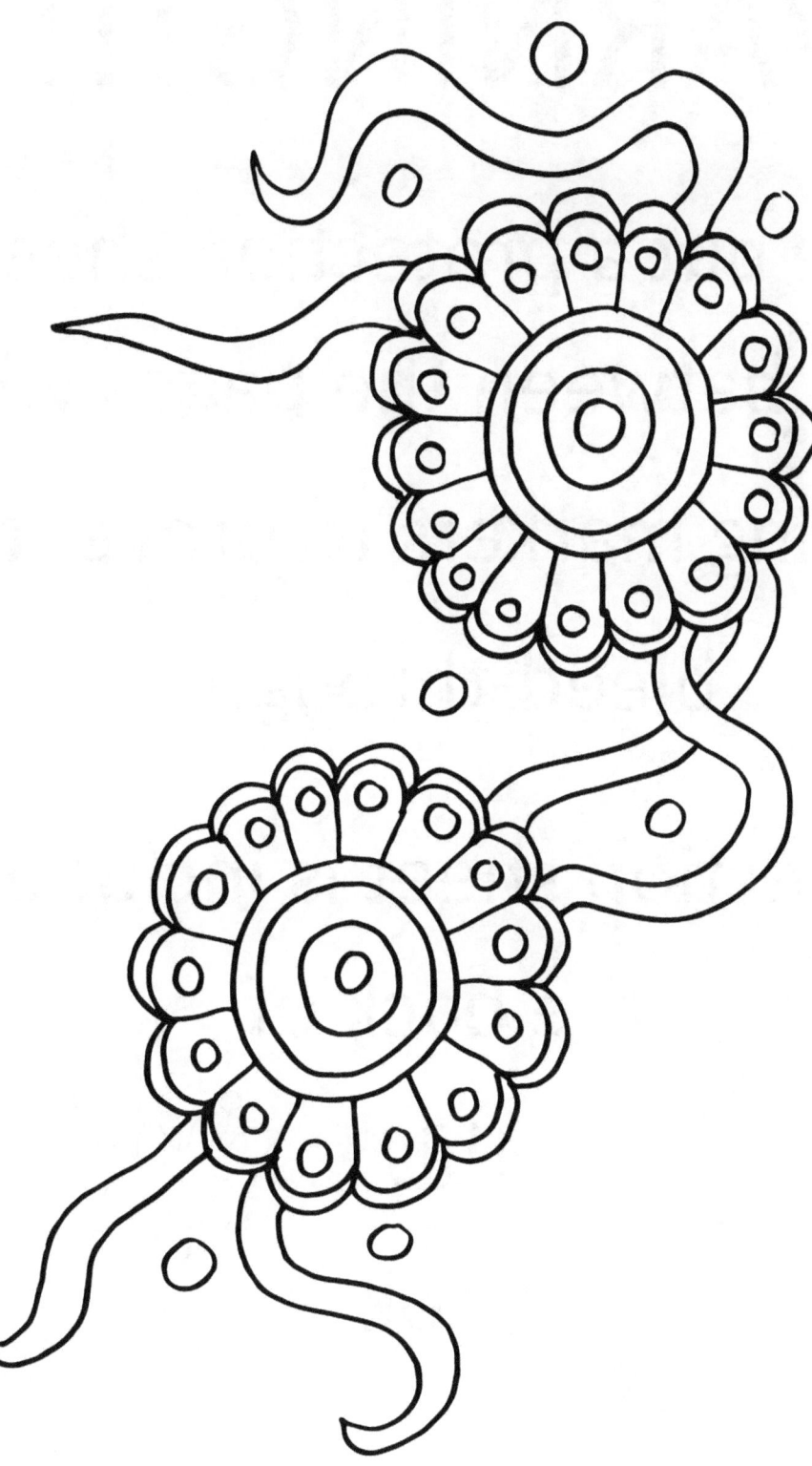

This book is dedicated to everyone I love.

WARNING!!!!

Please put a protection sheet of paper between the pages when using markers to prevent bleed-through.

A protection sheet is included at the back of this book.

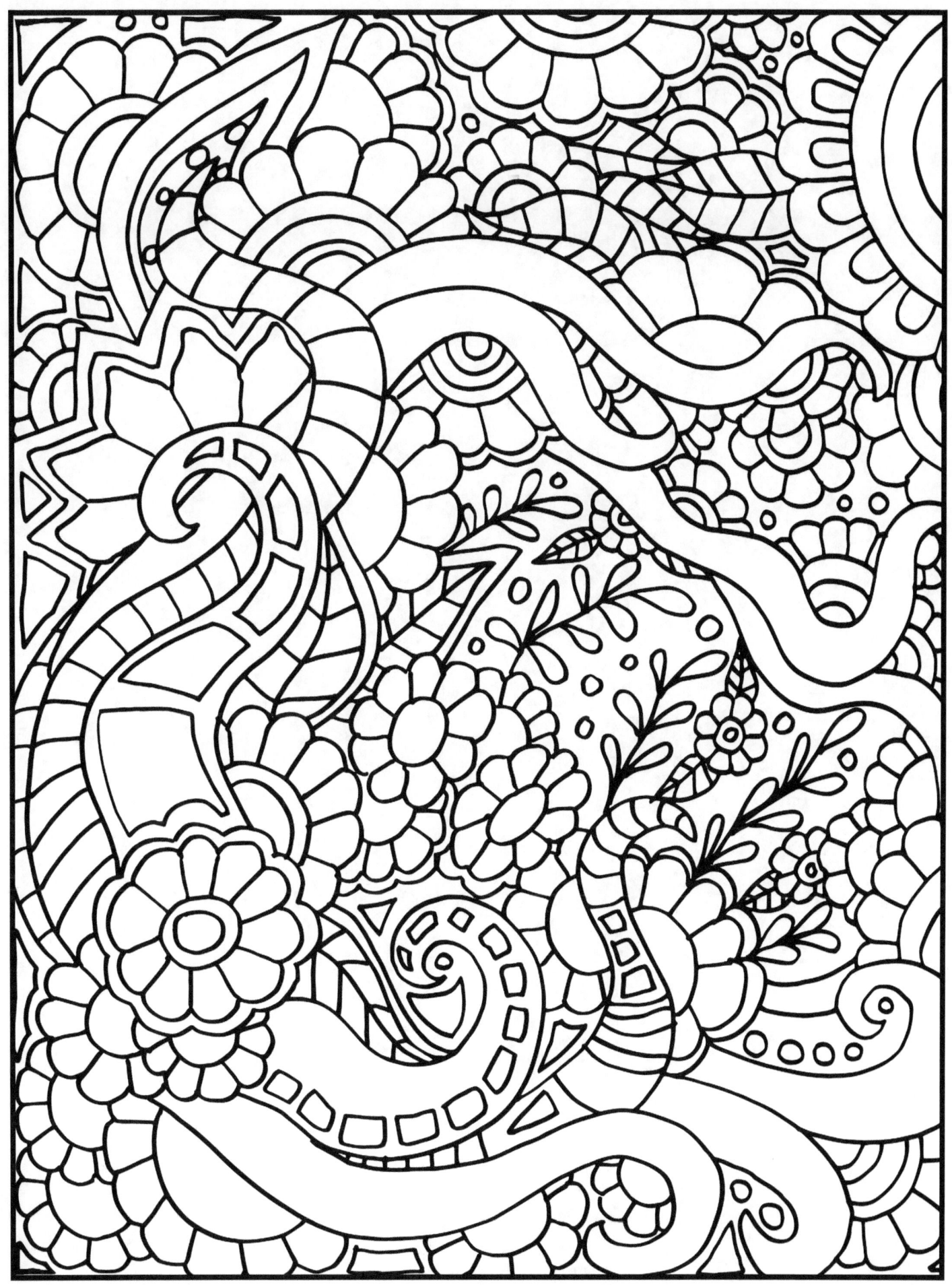

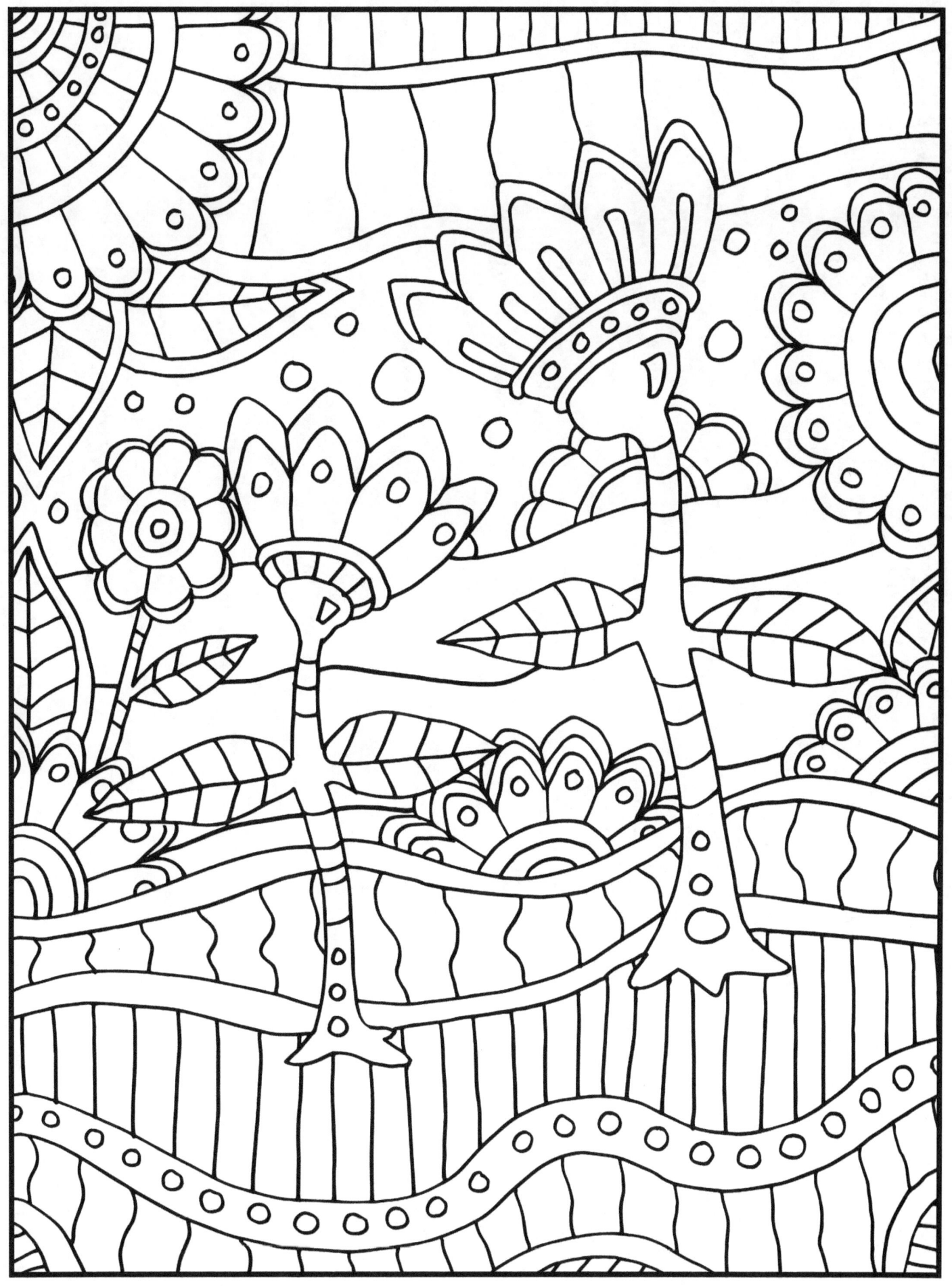

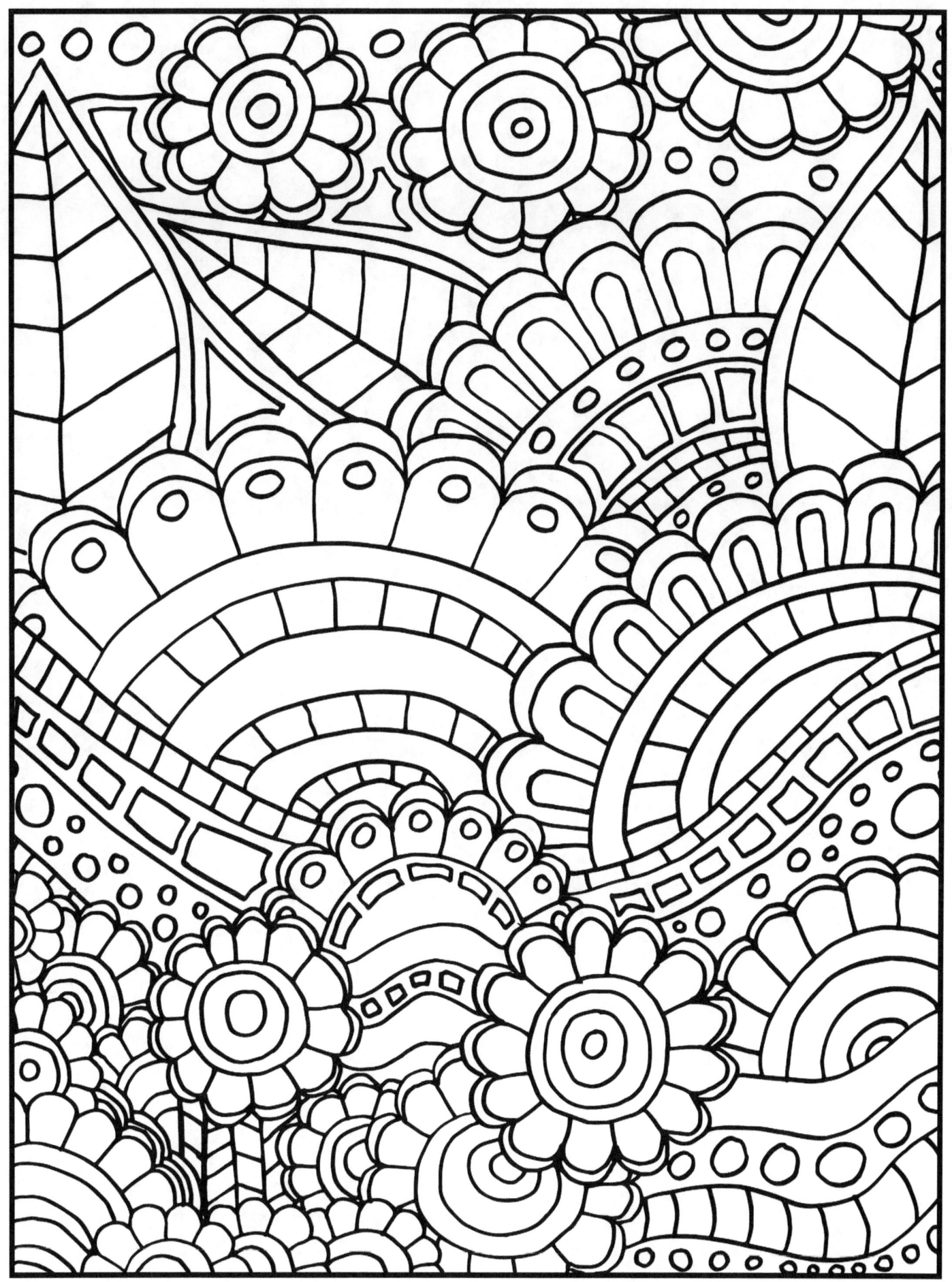

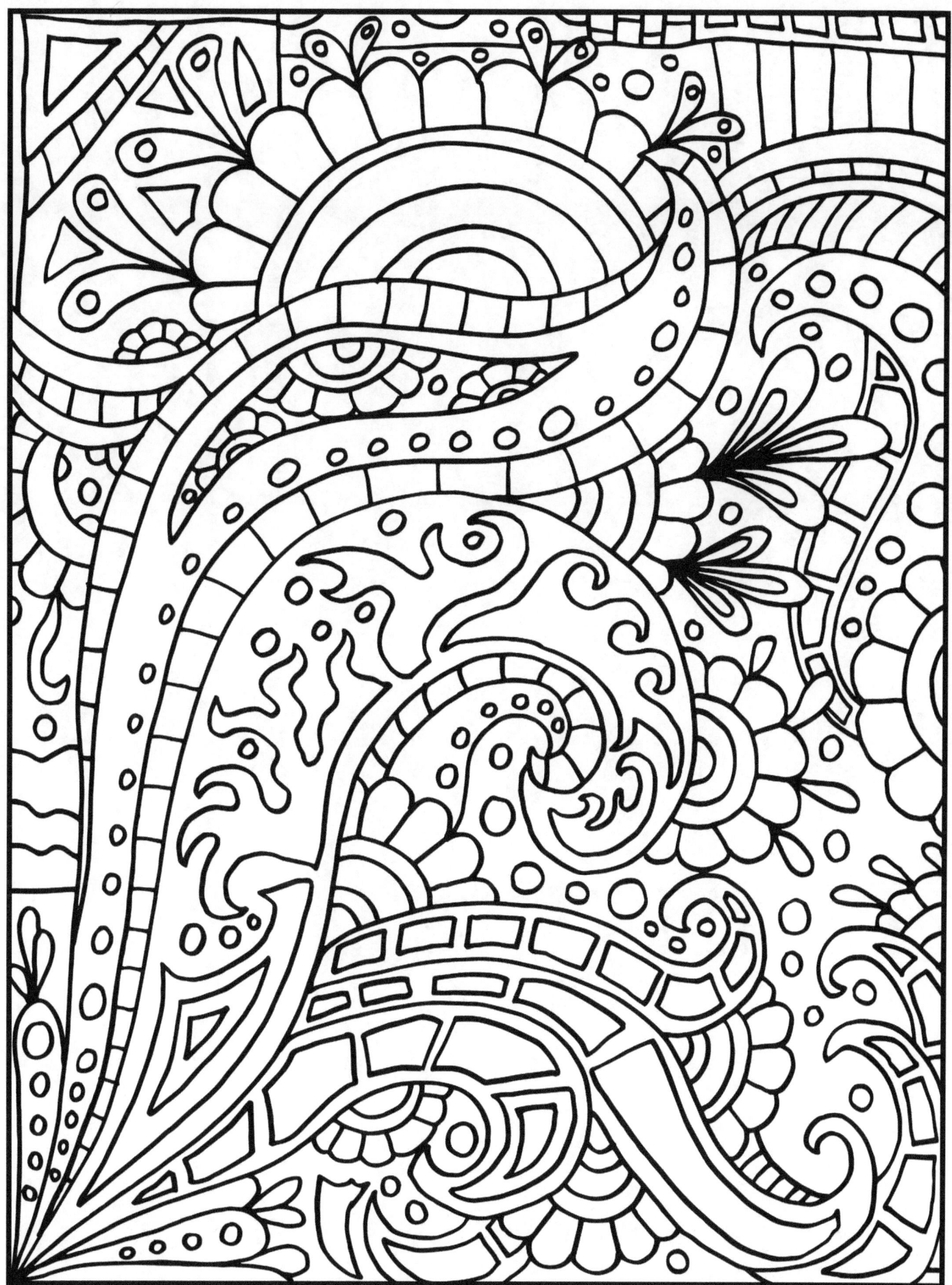

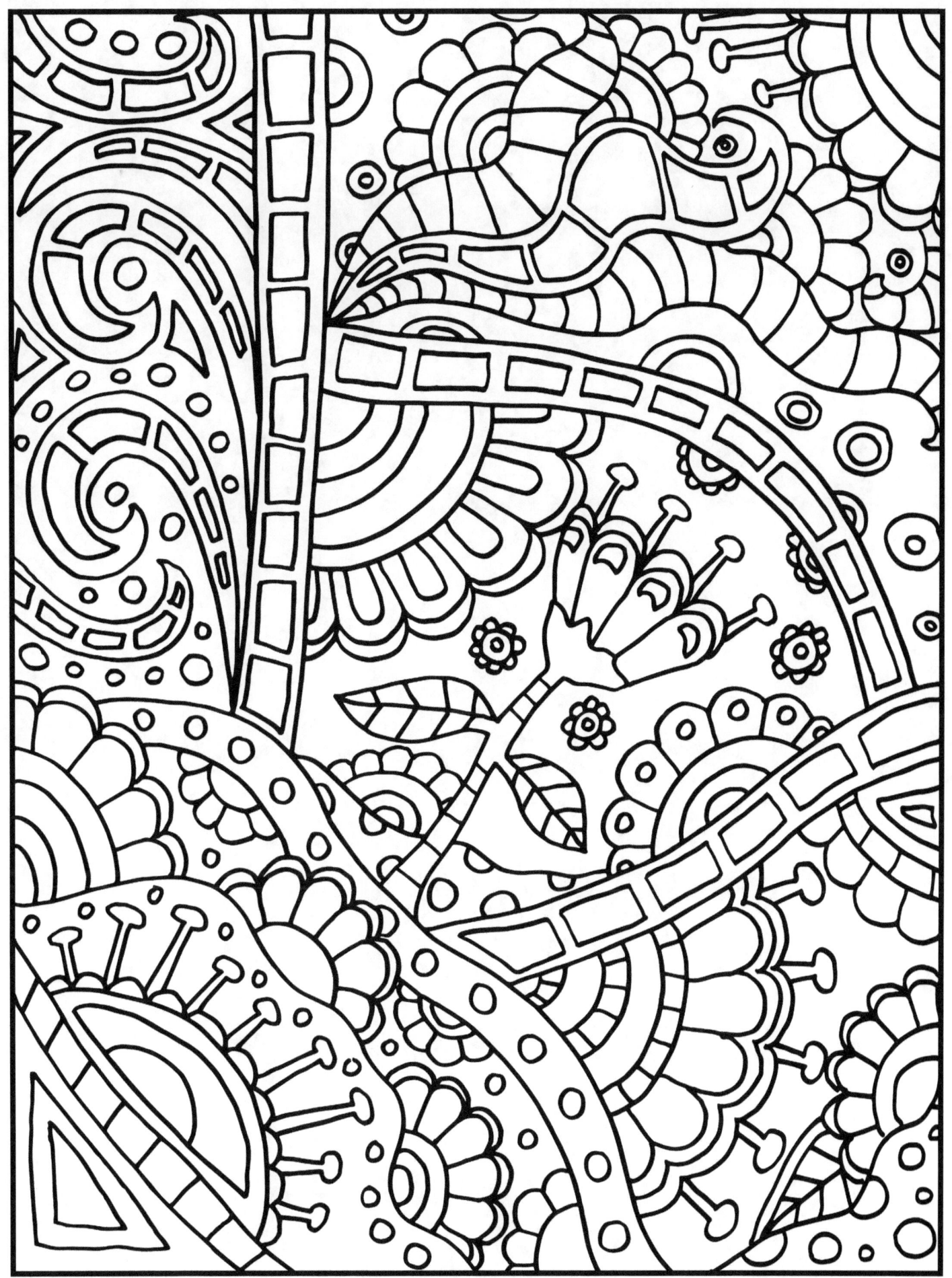

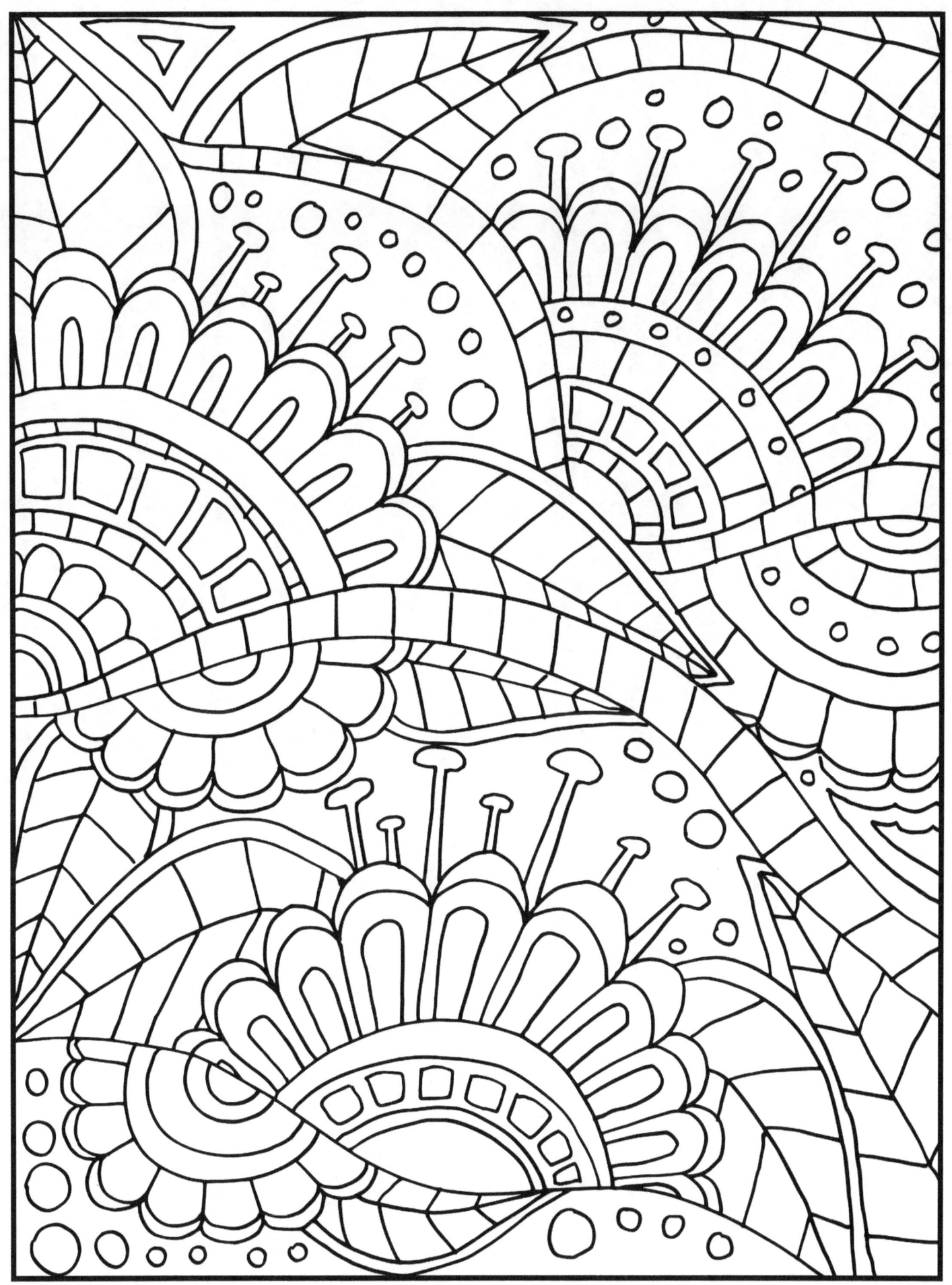

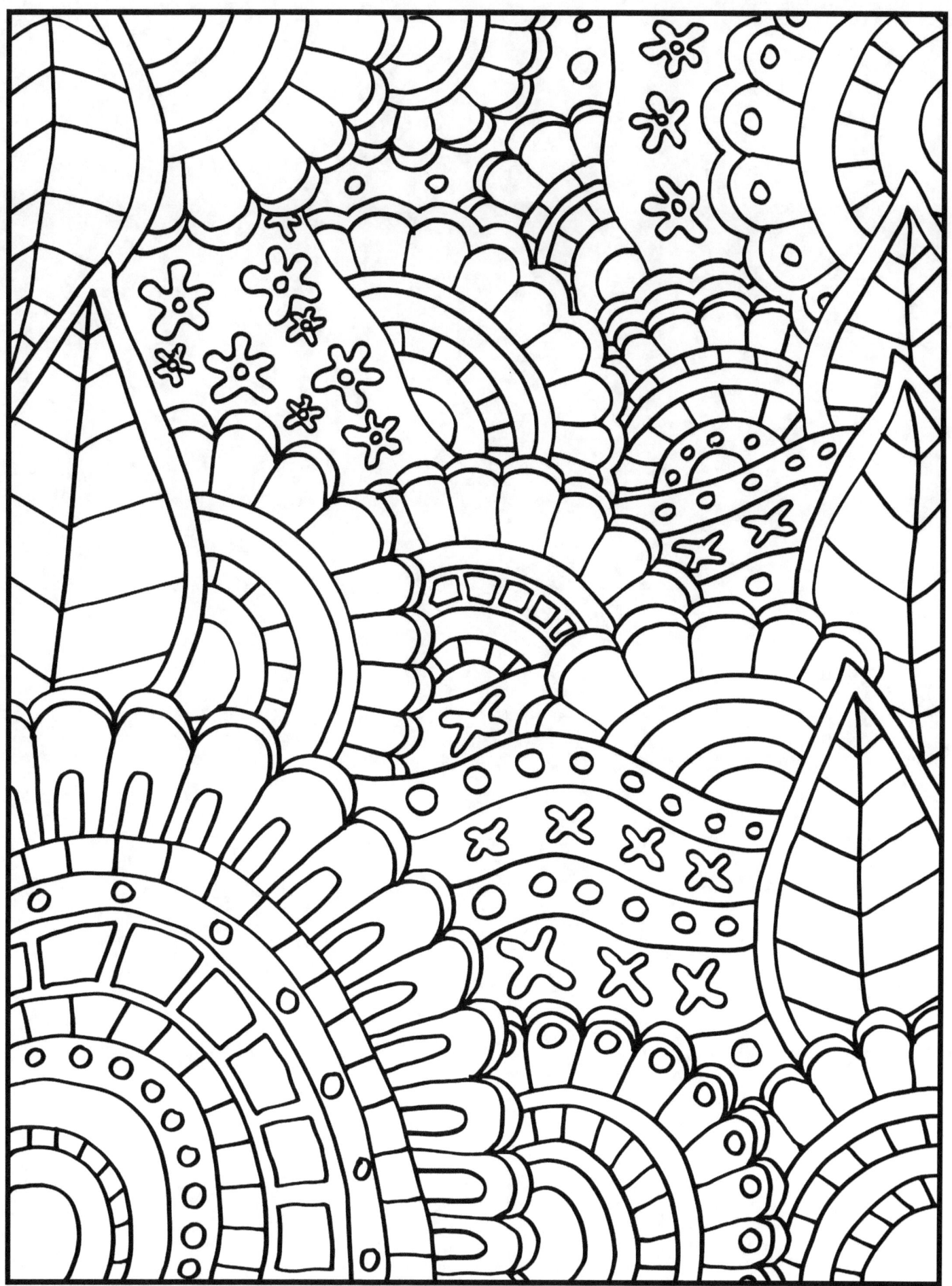

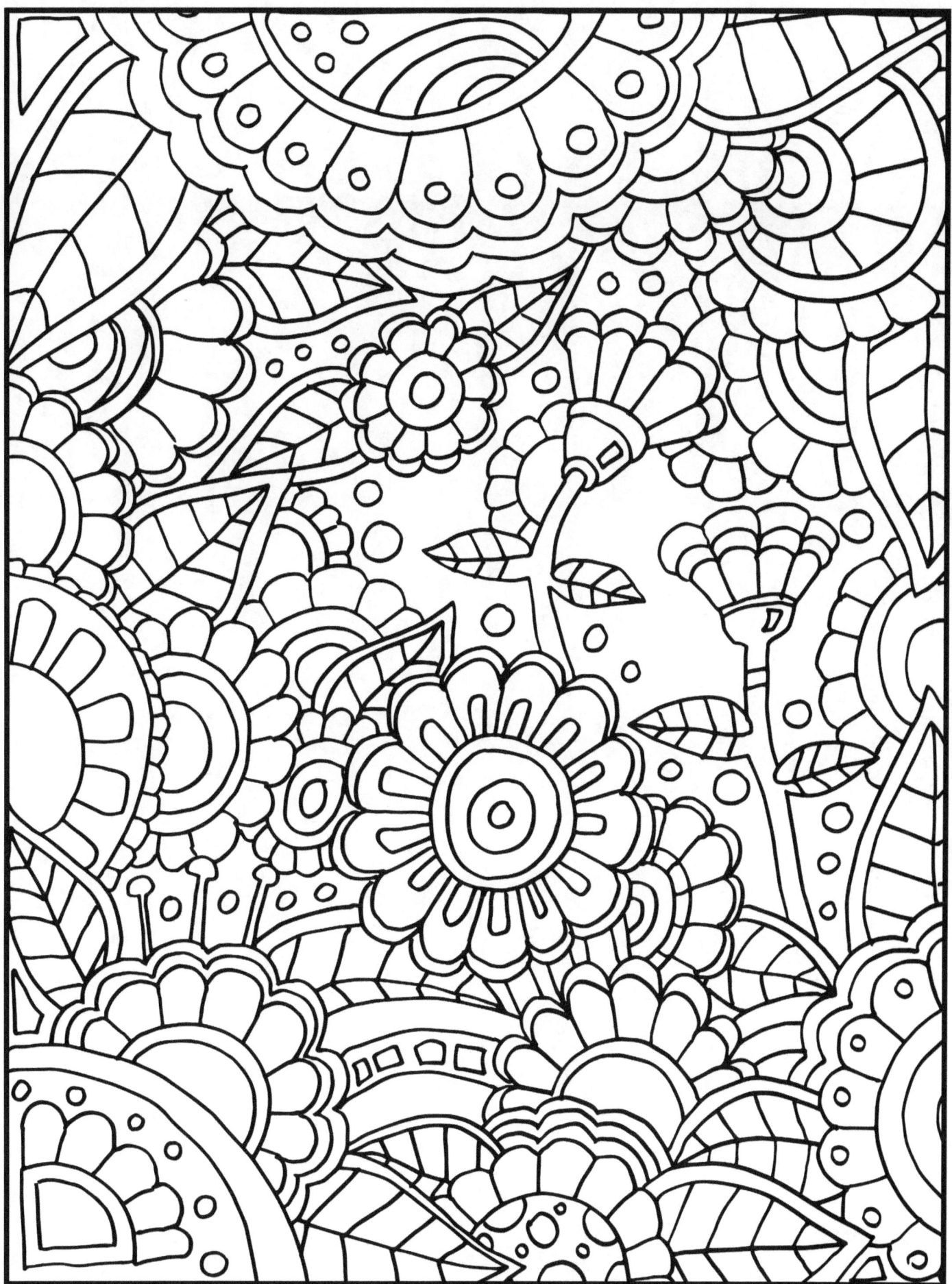

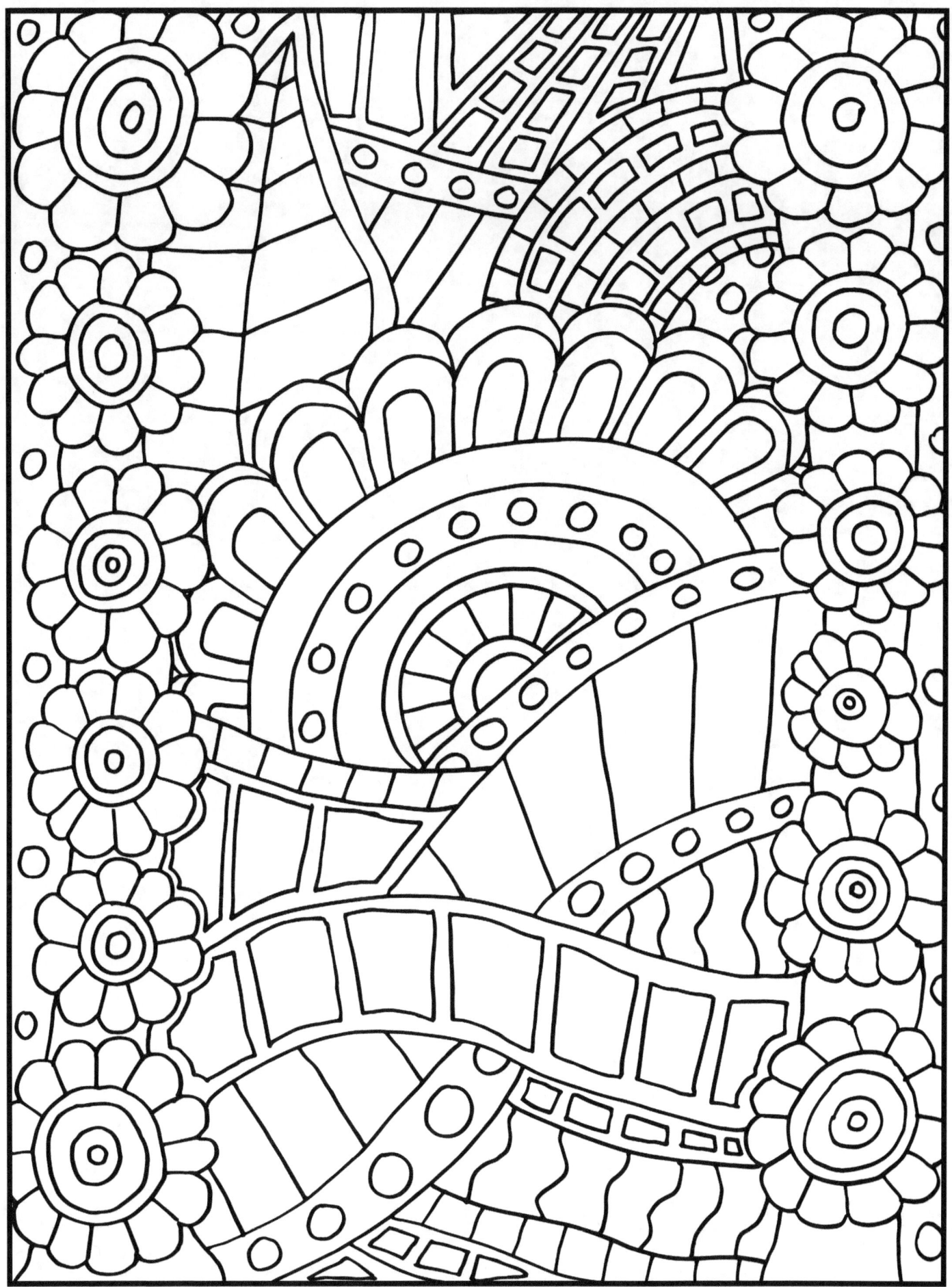

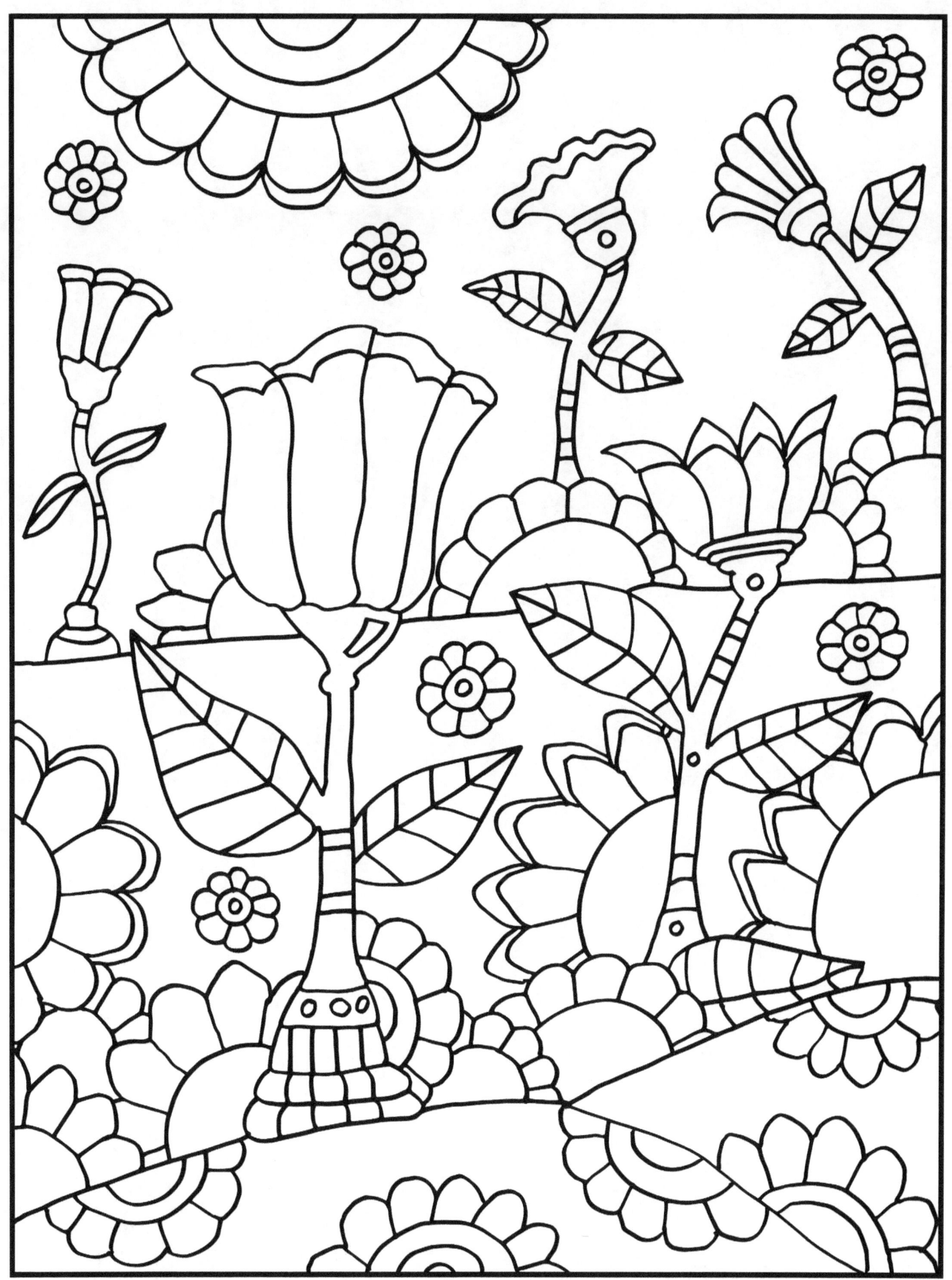

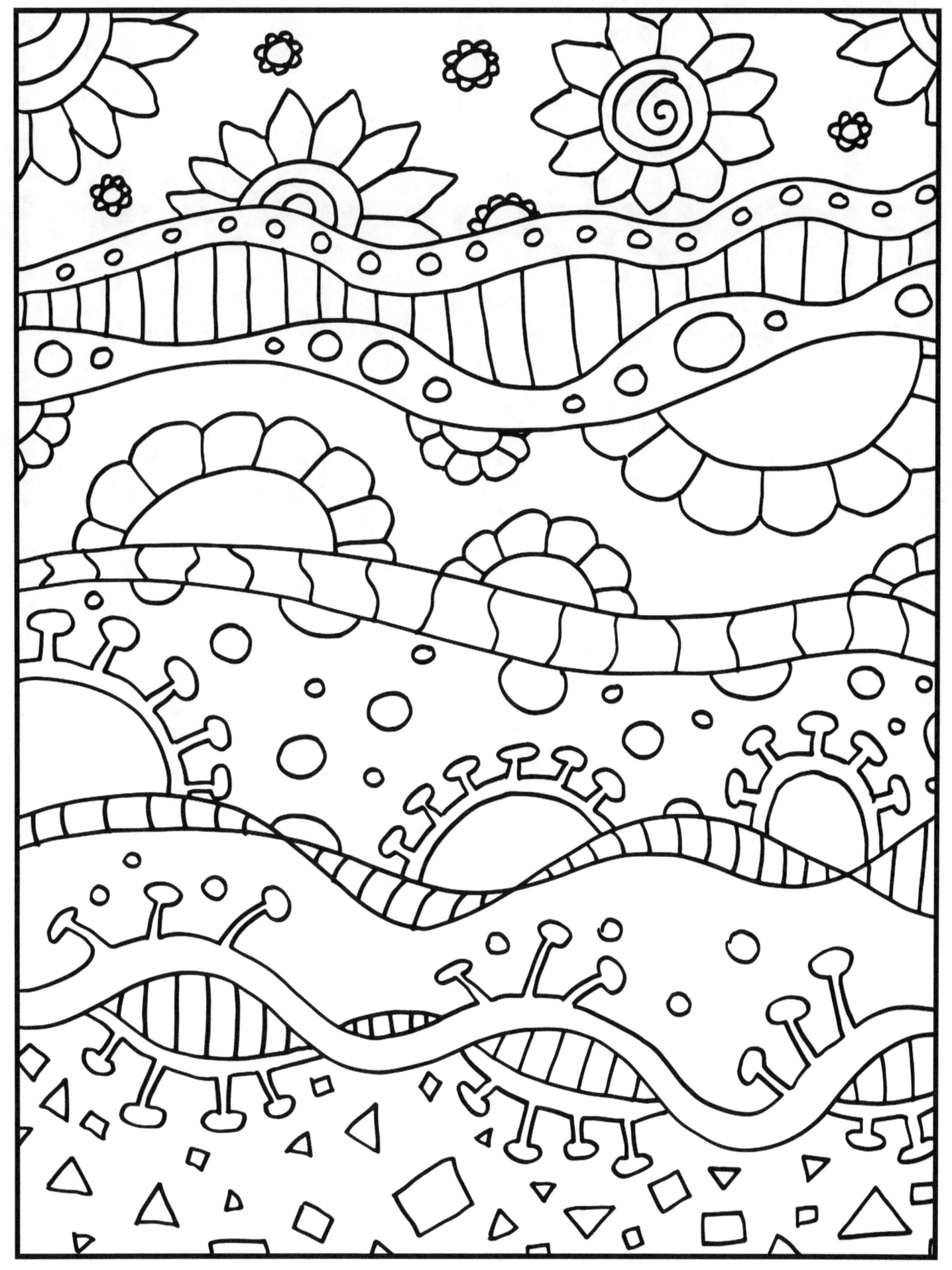

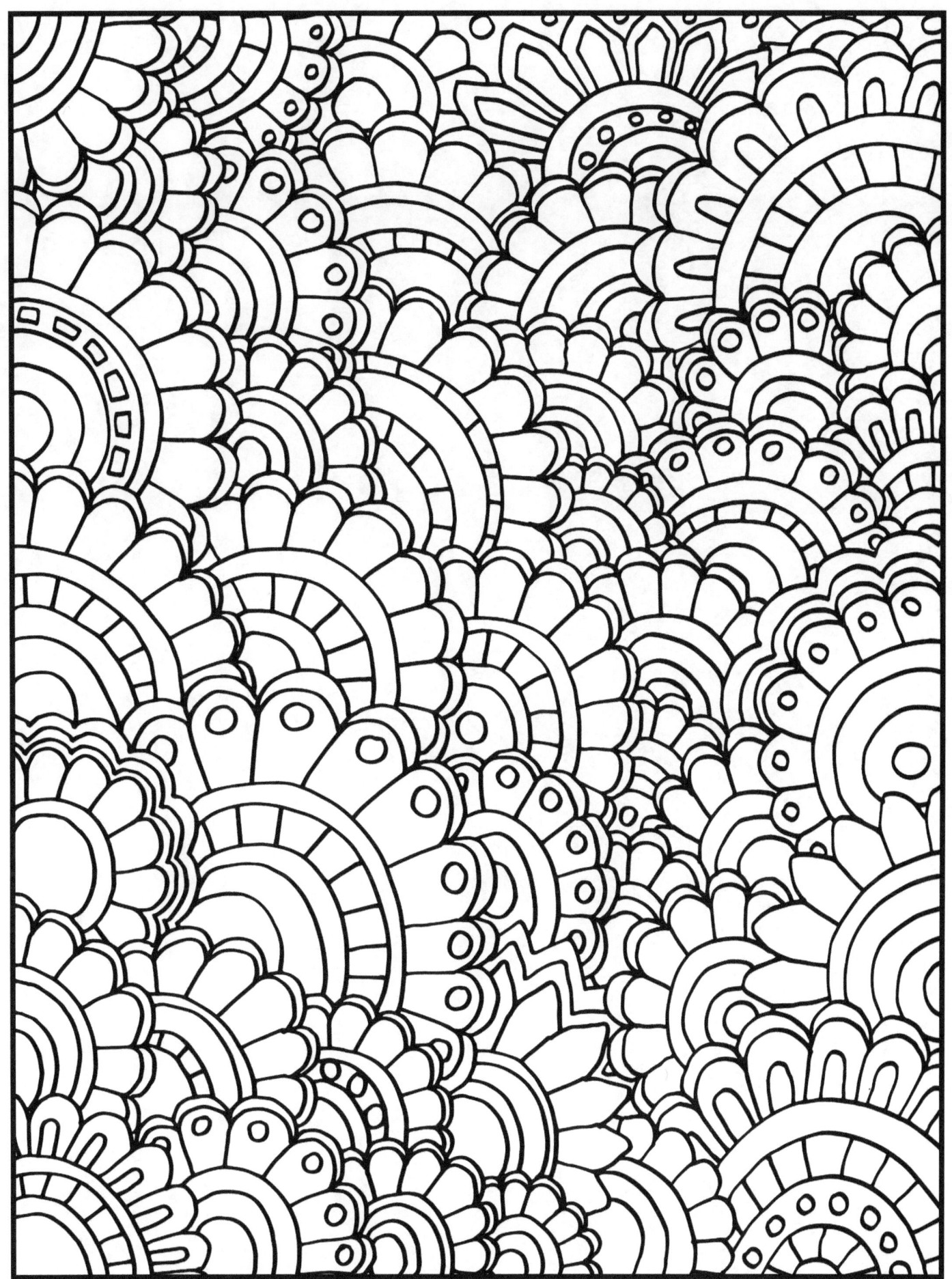

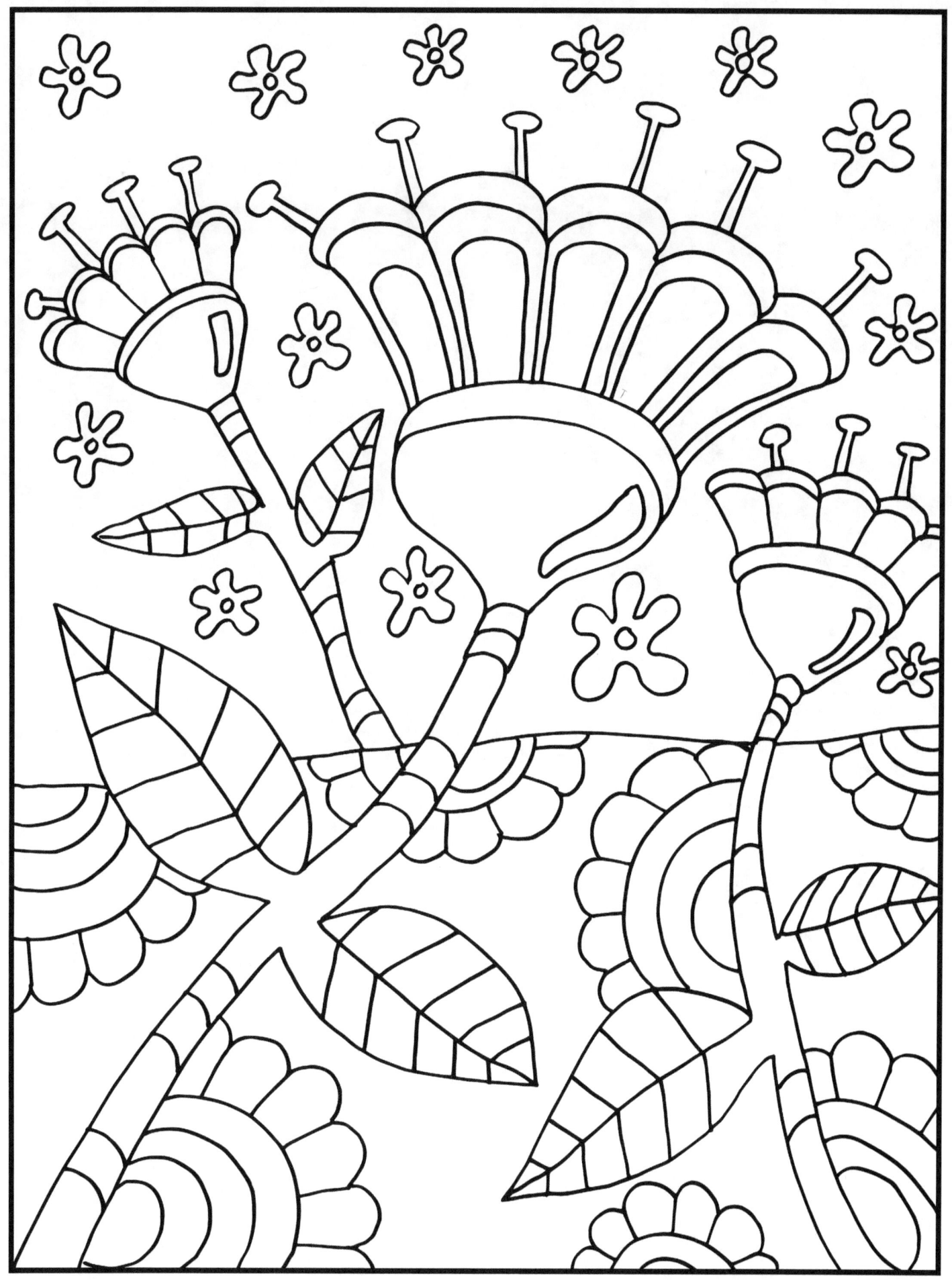

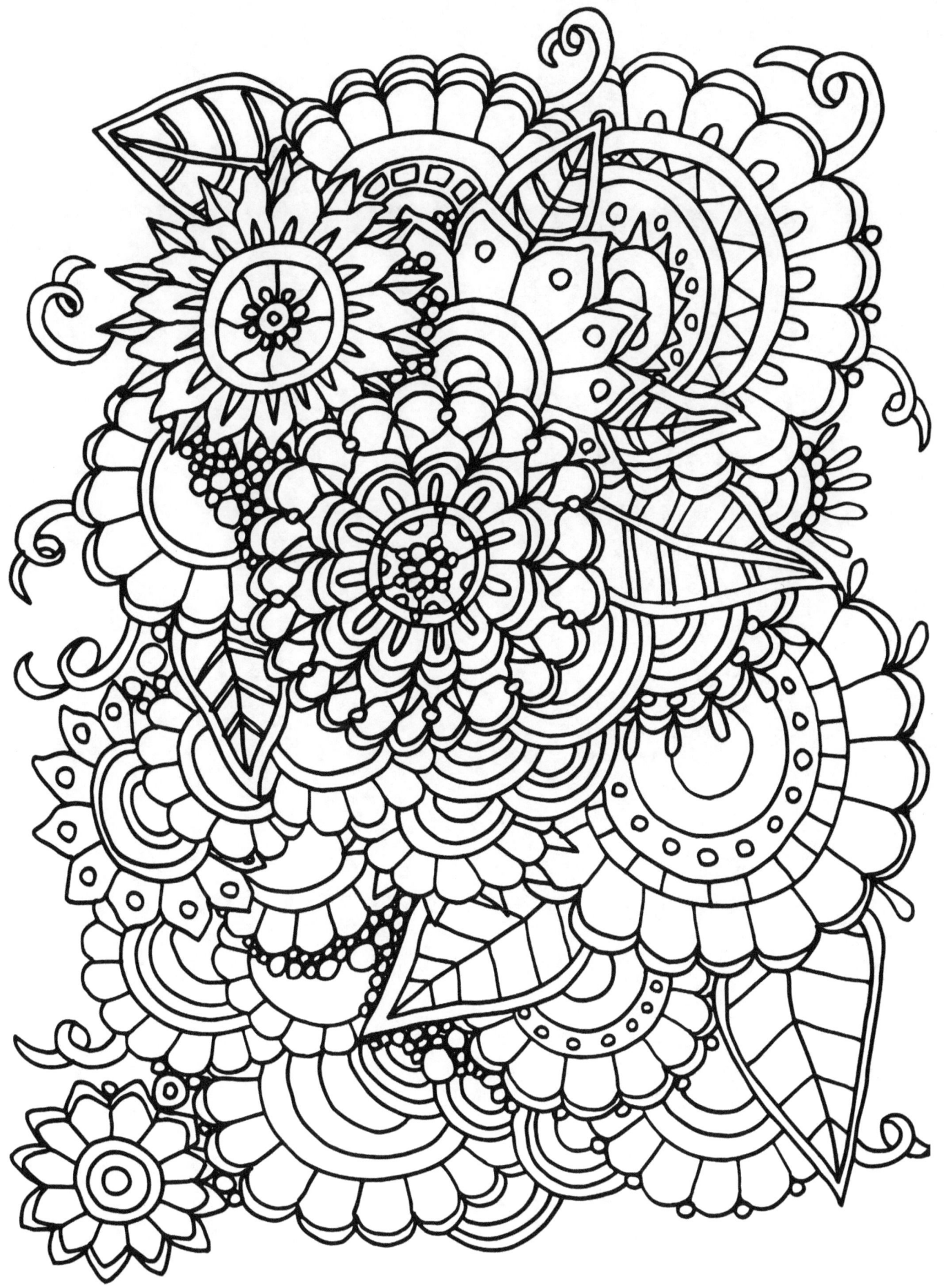

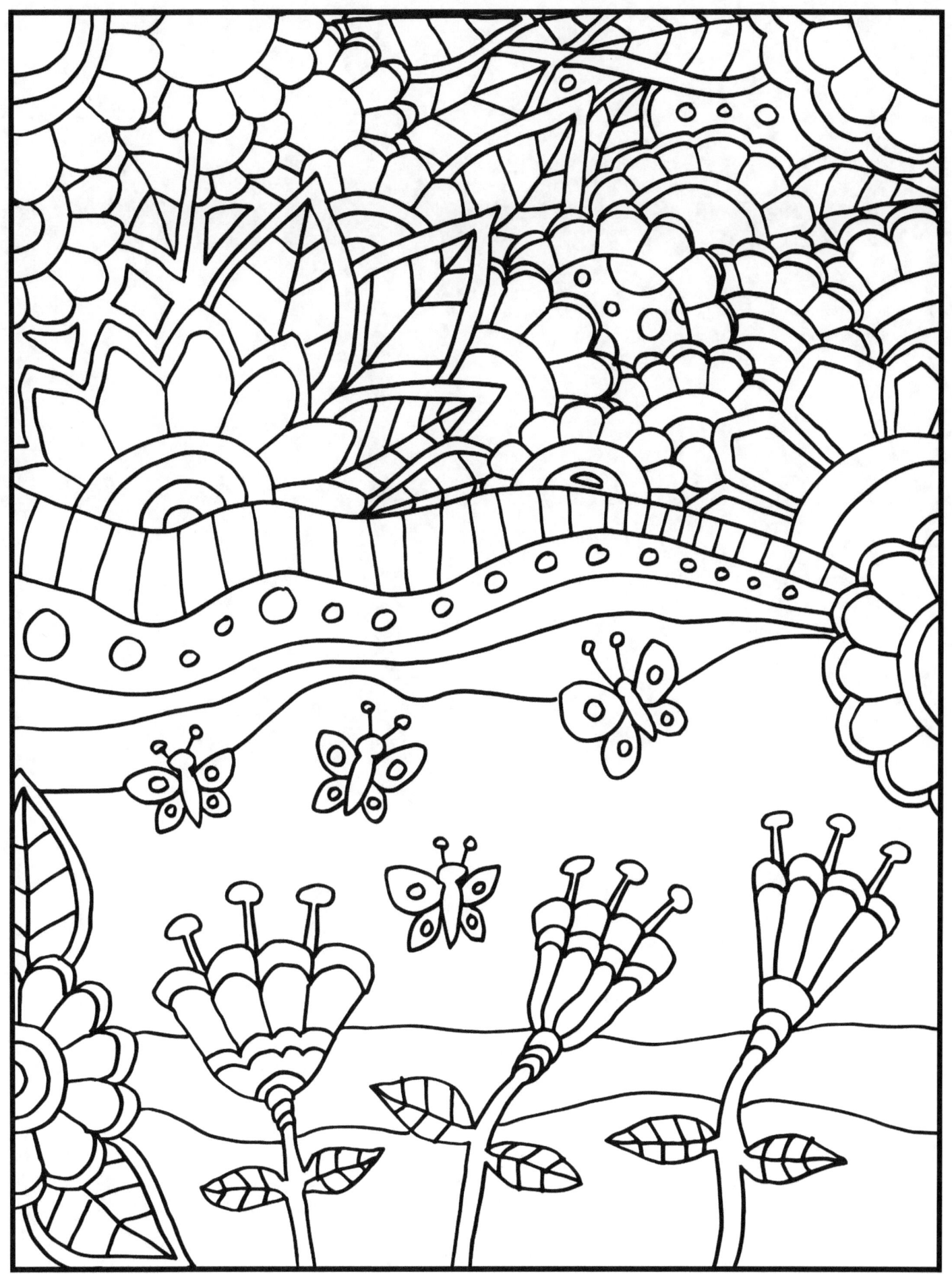

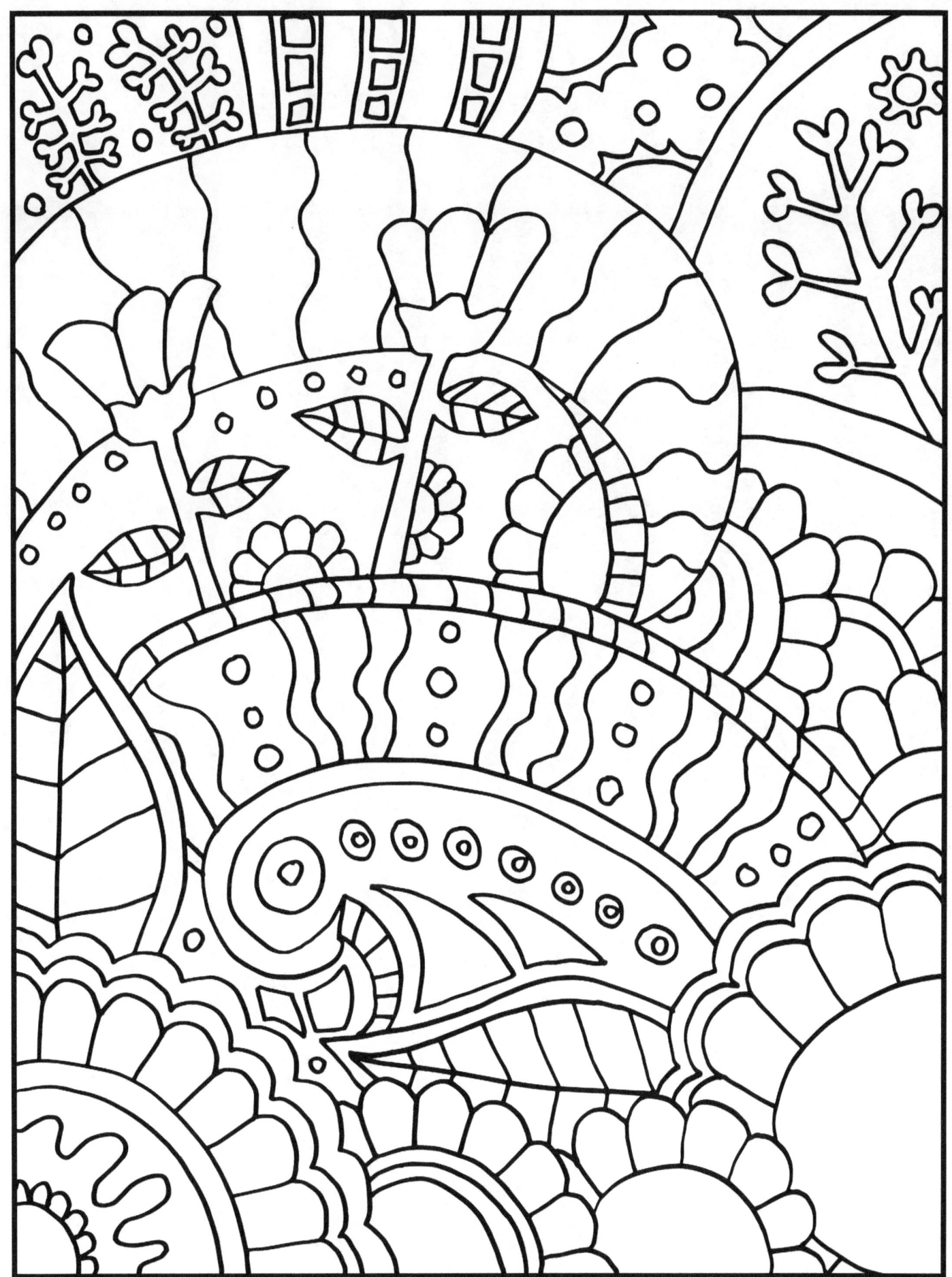

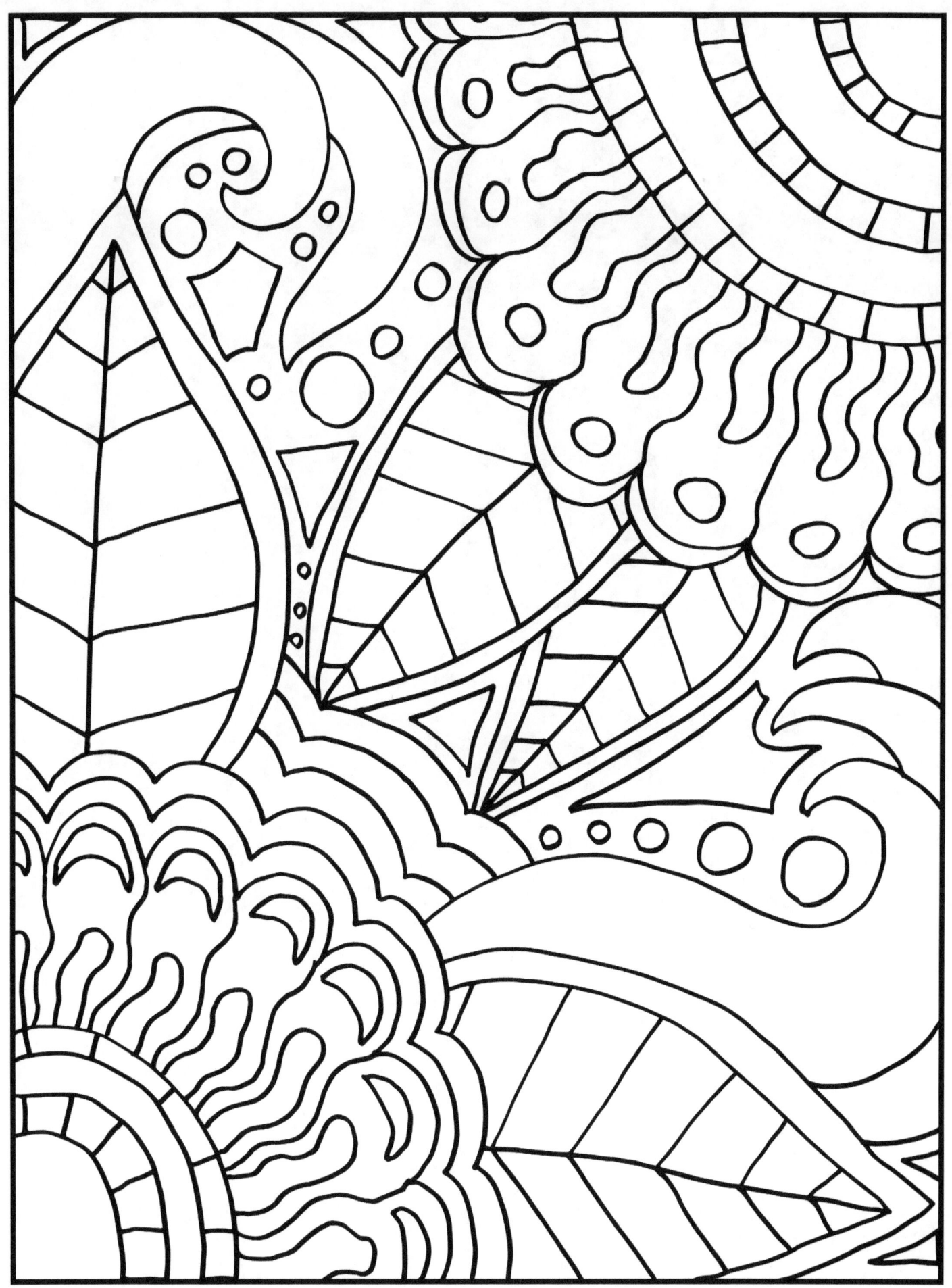

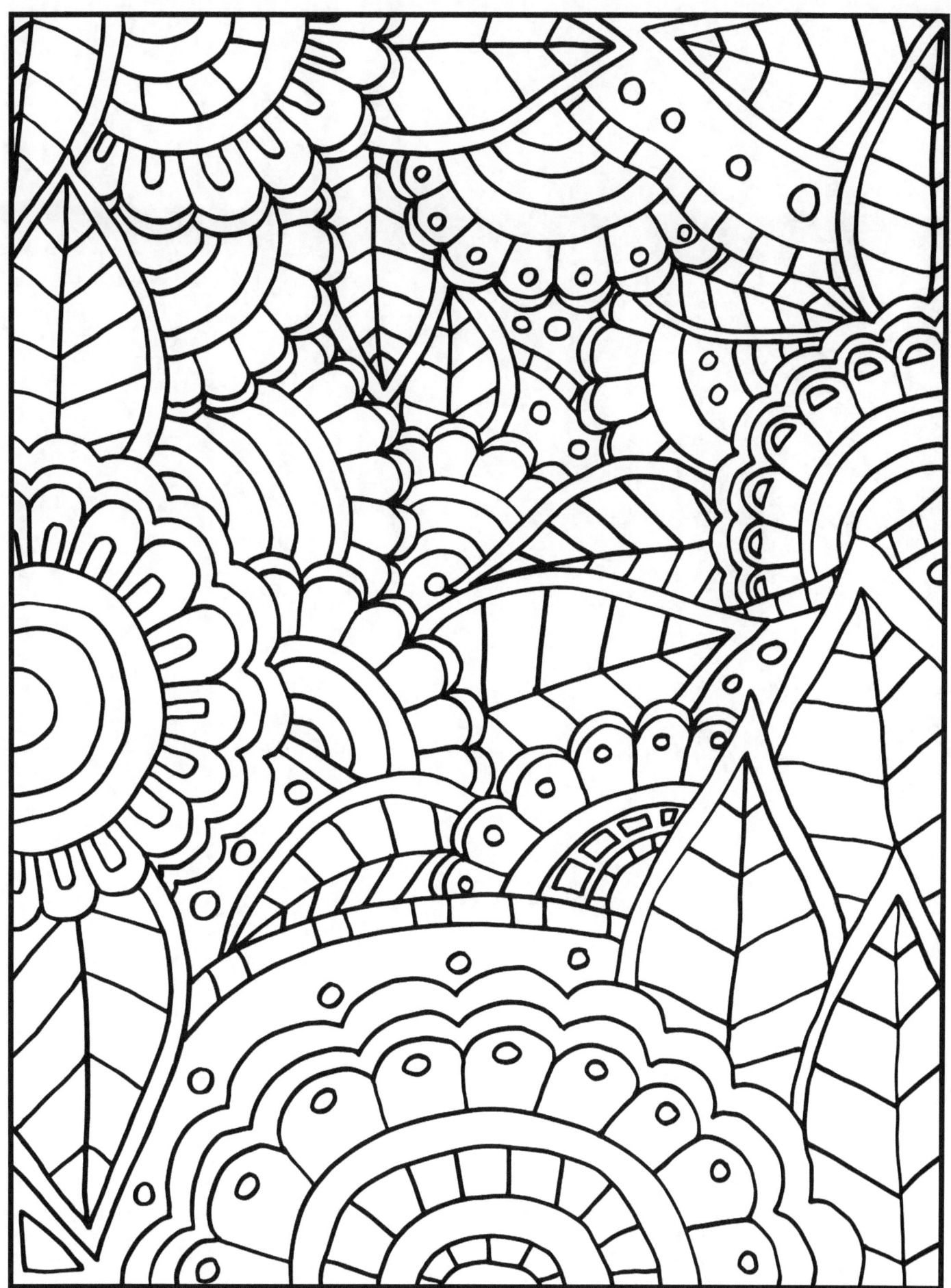

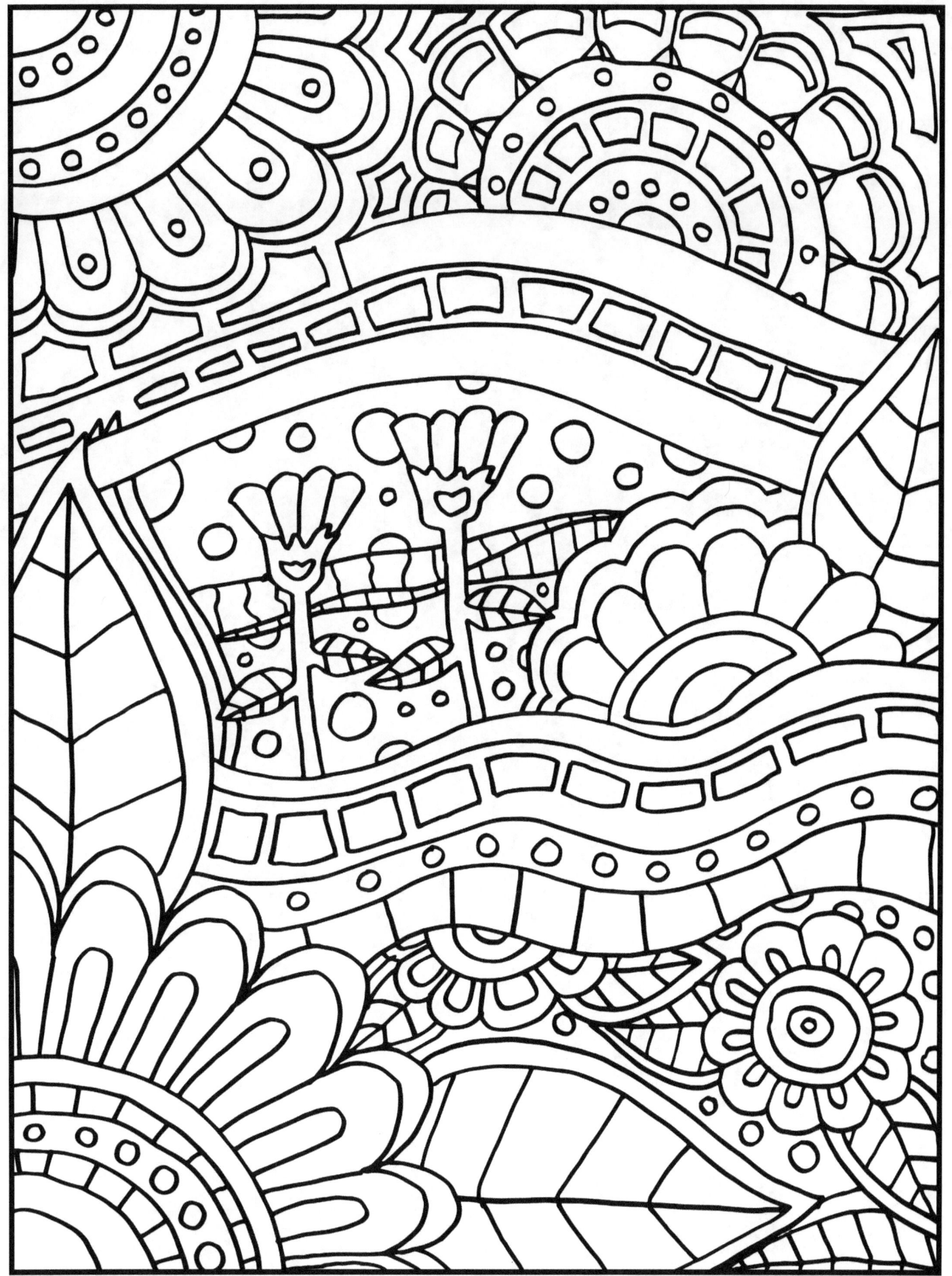

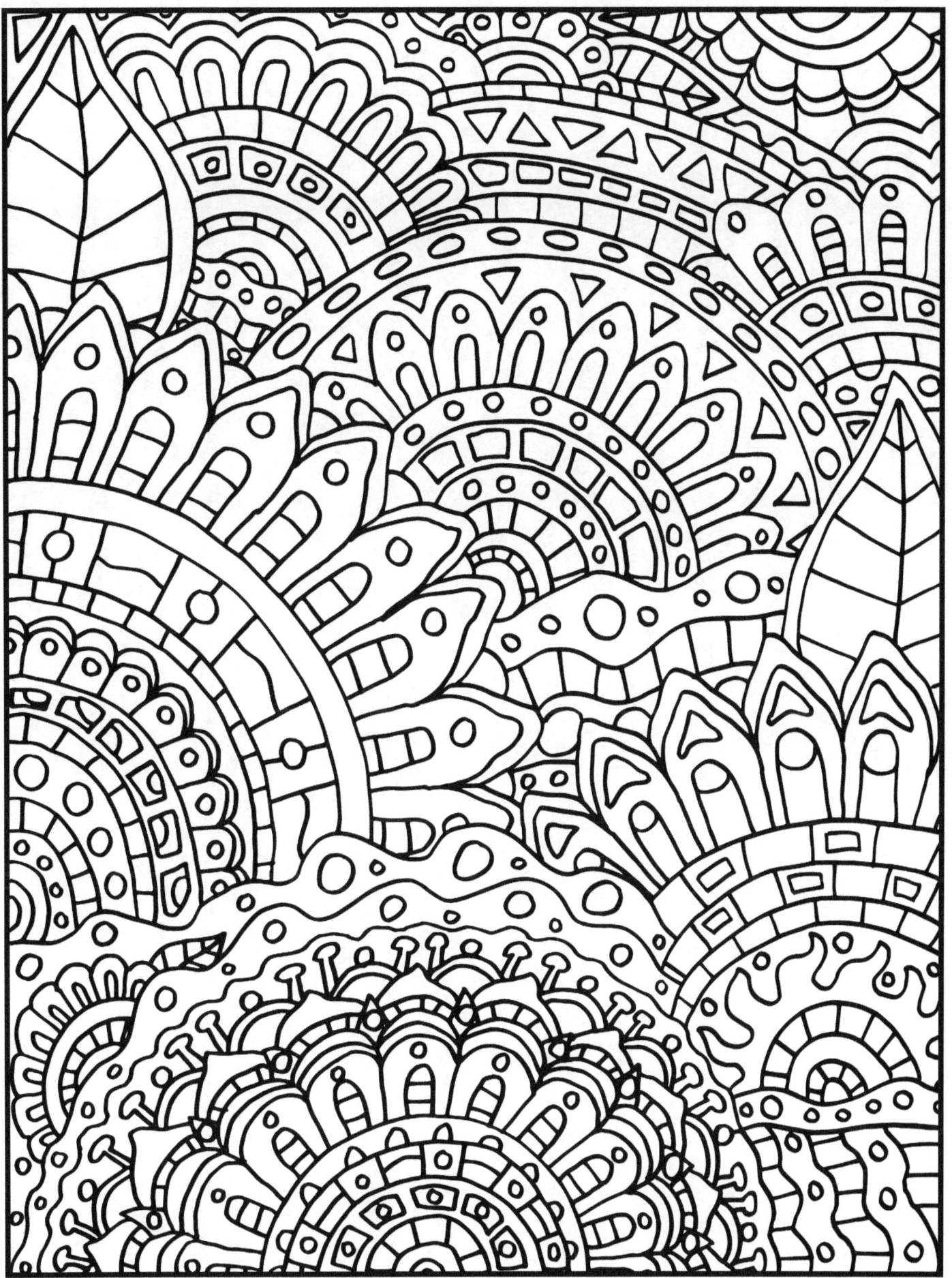

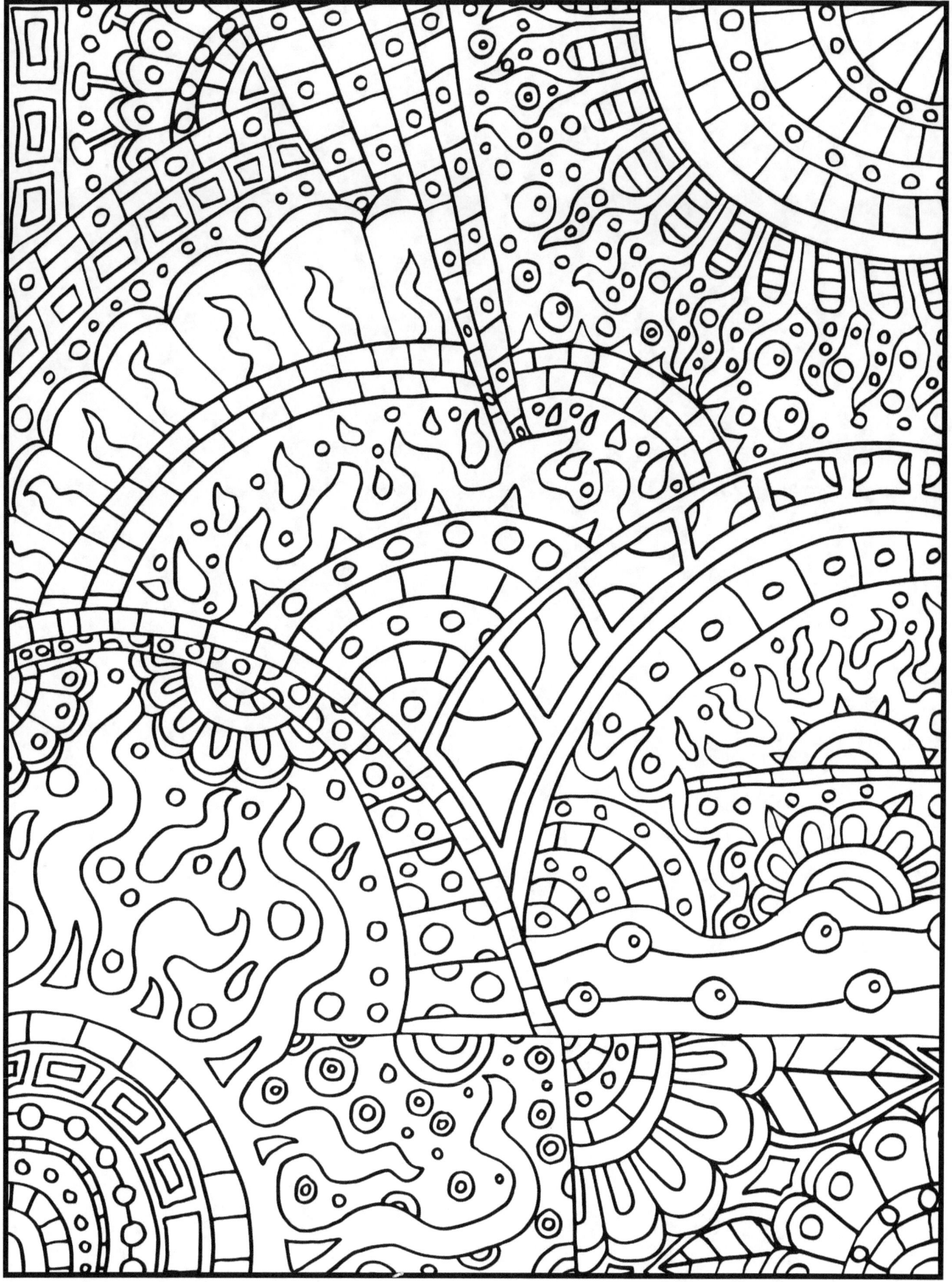

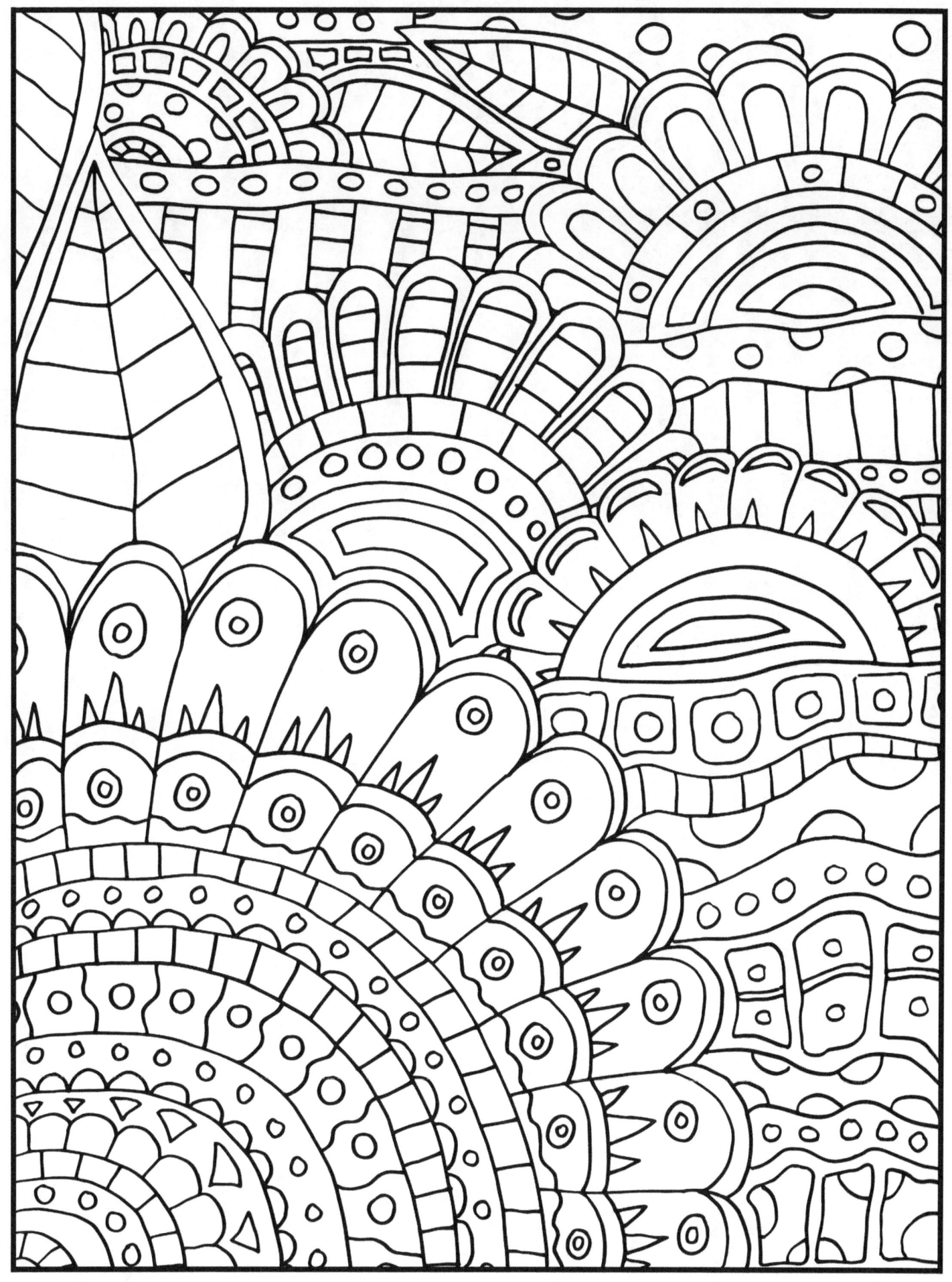

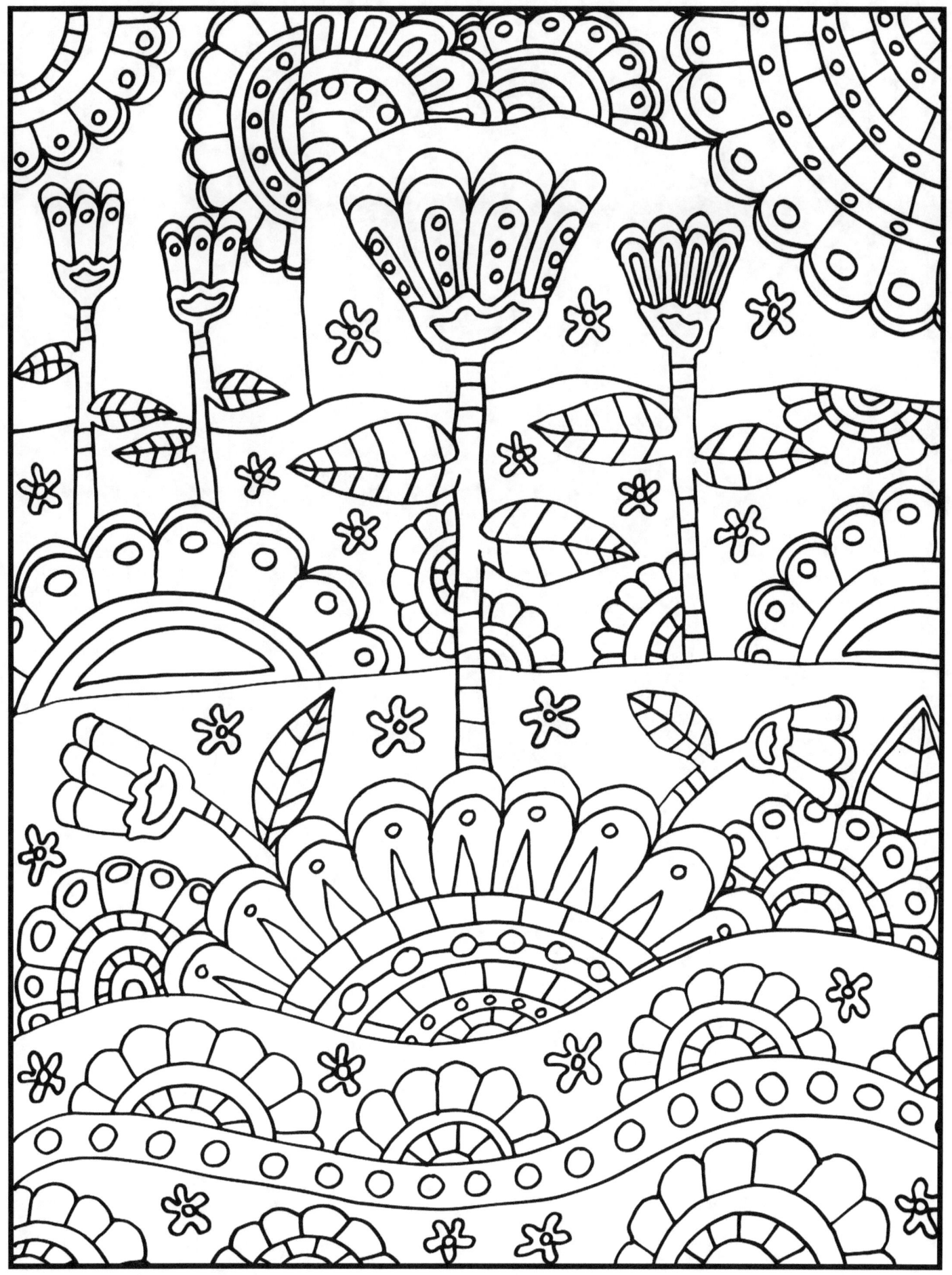

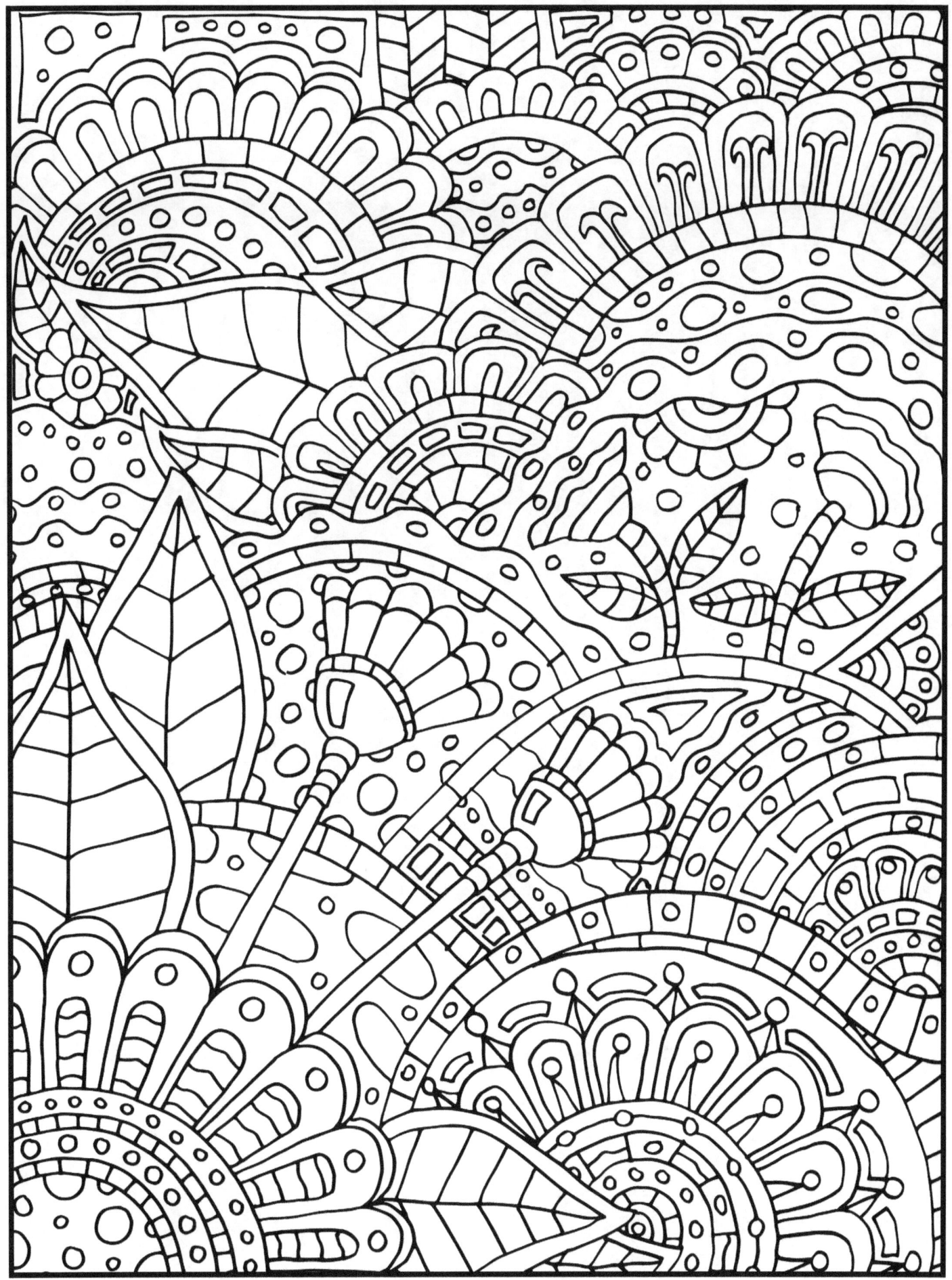

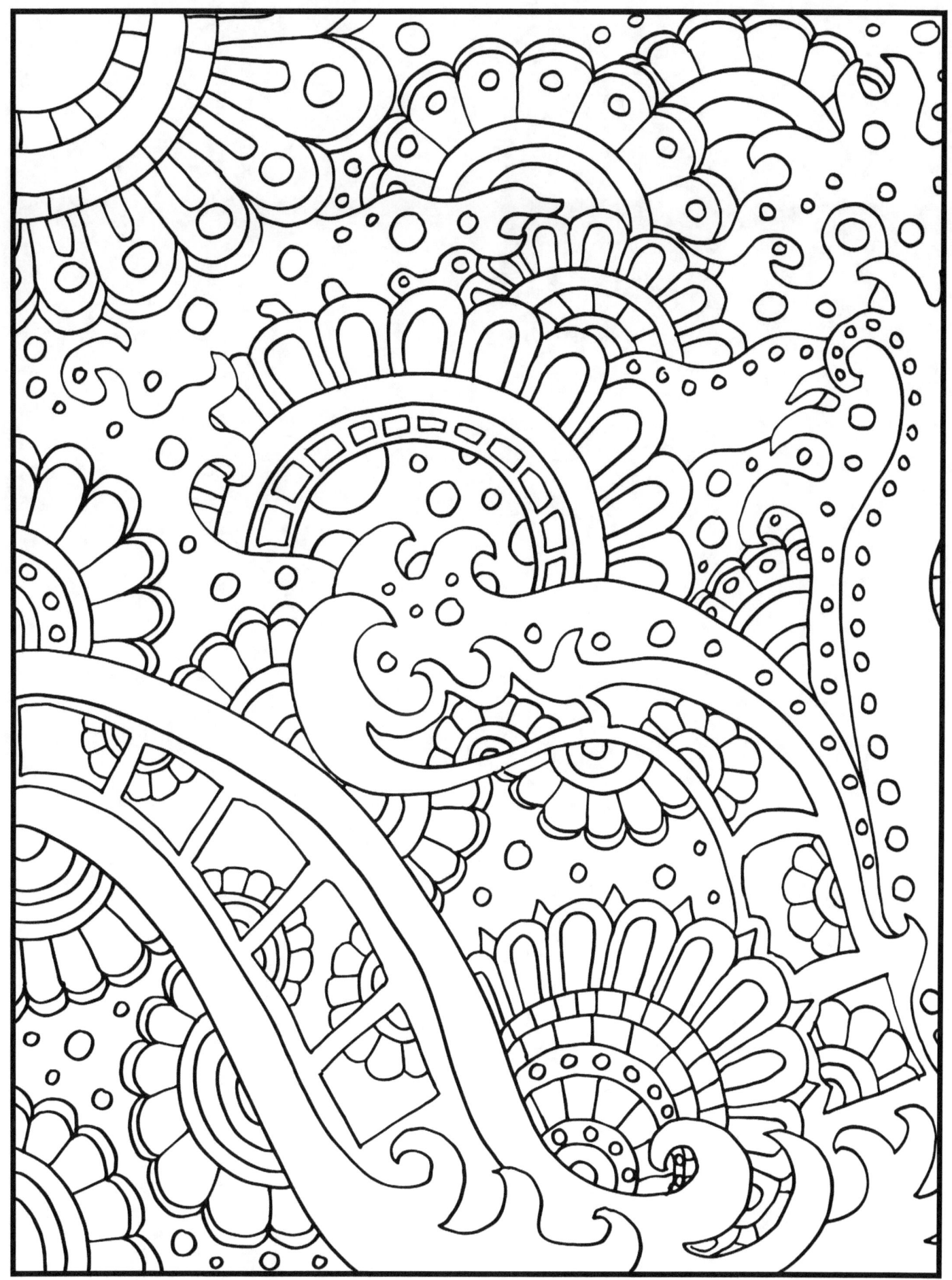

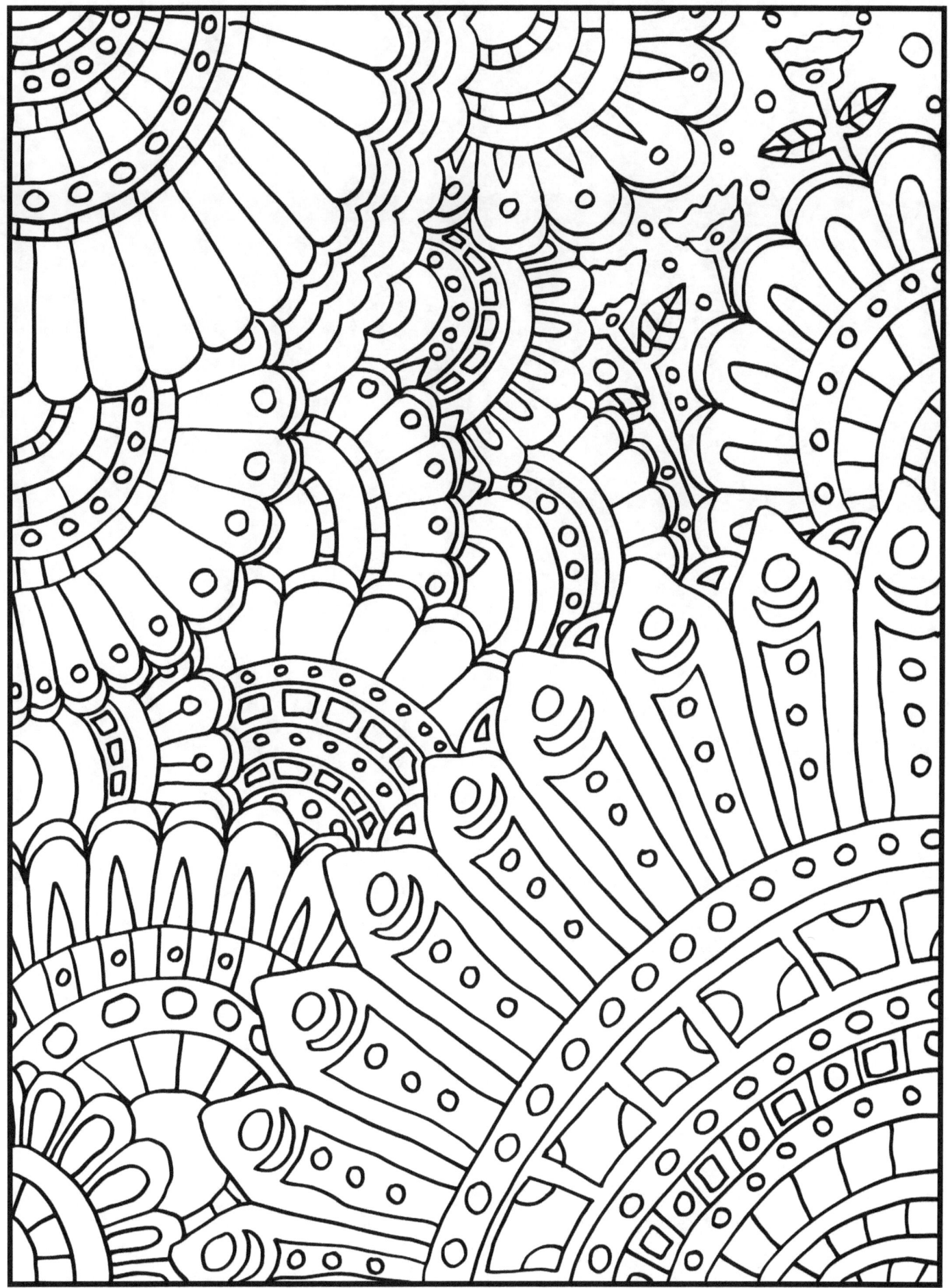

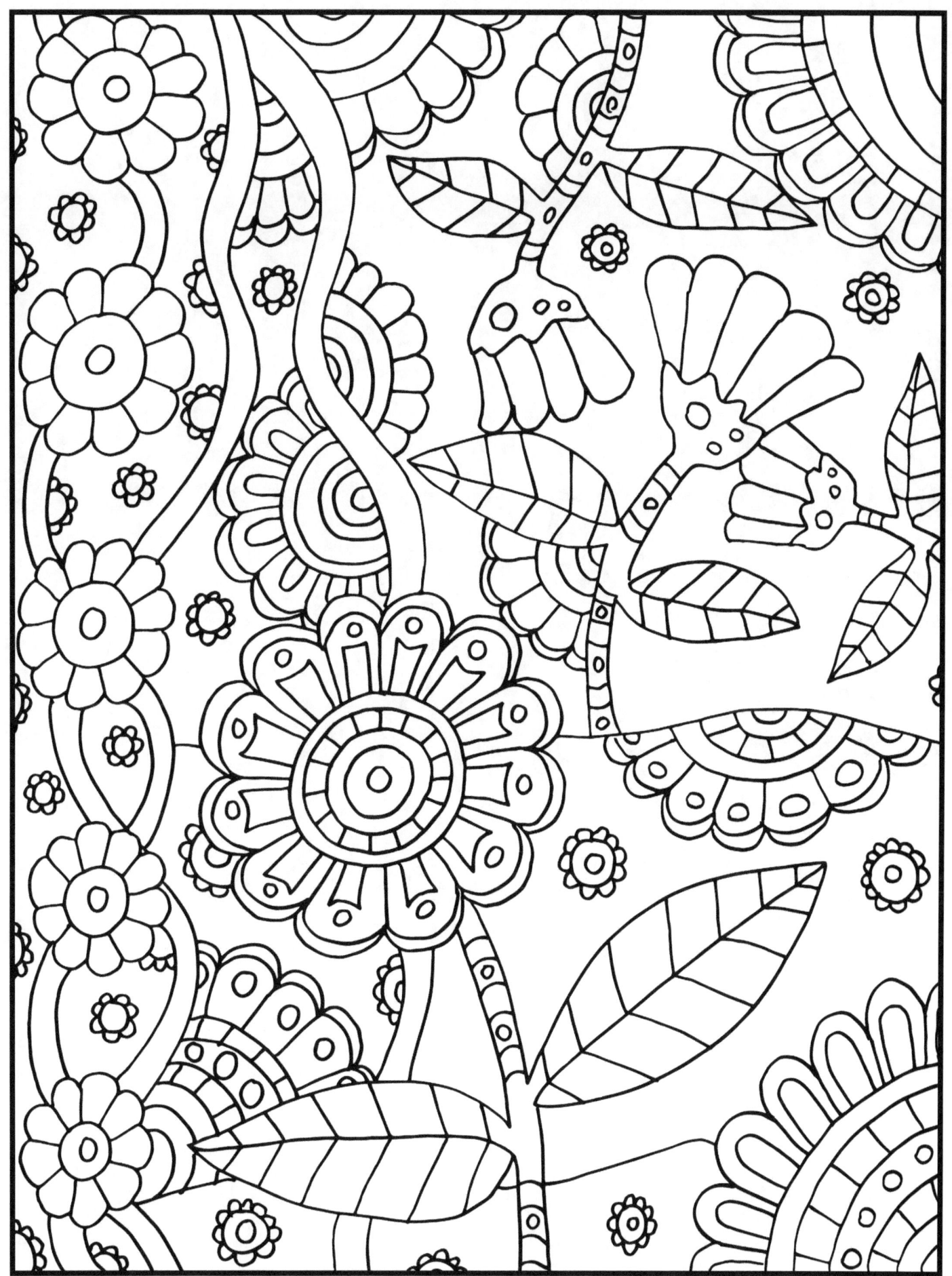

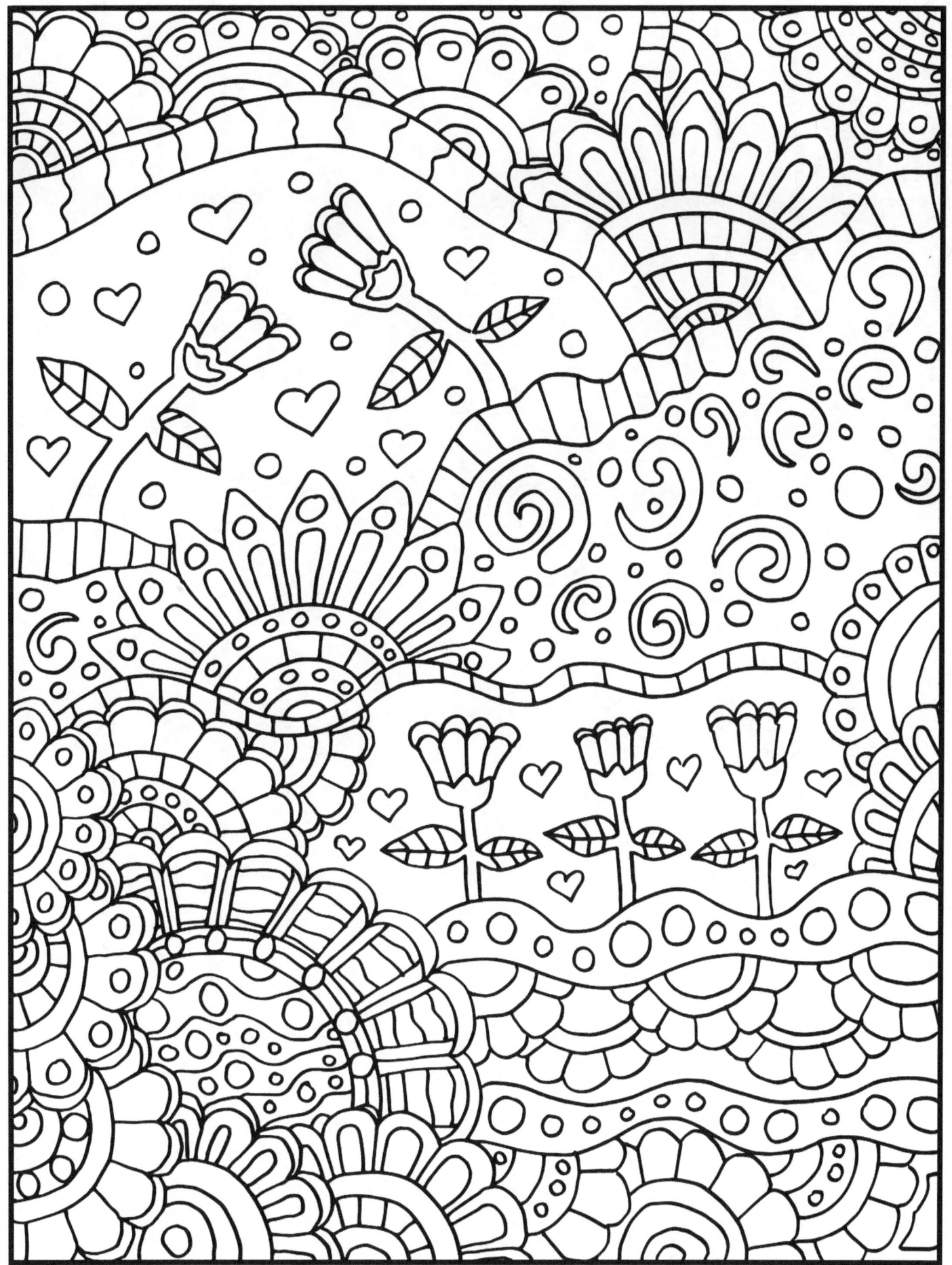

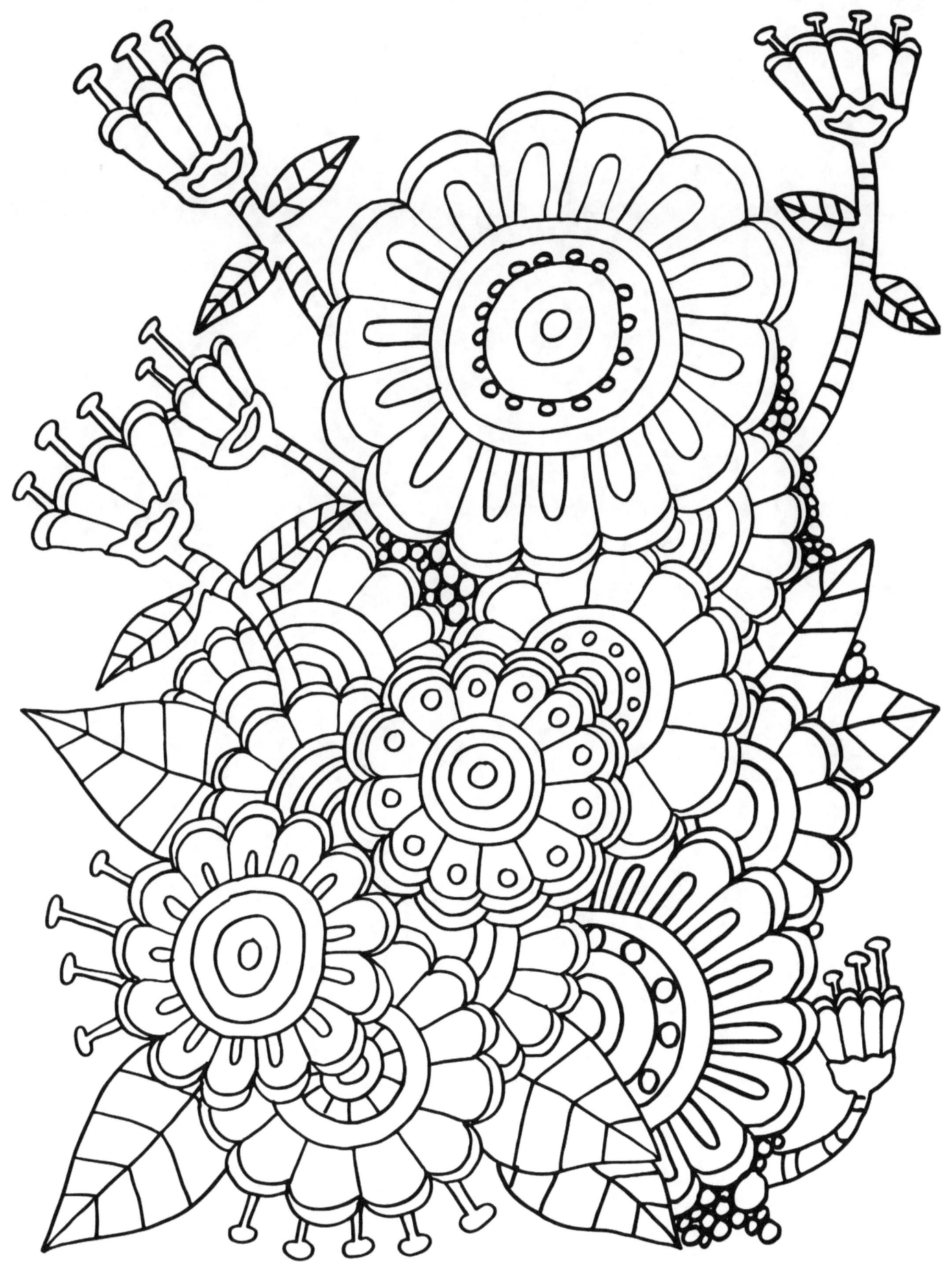

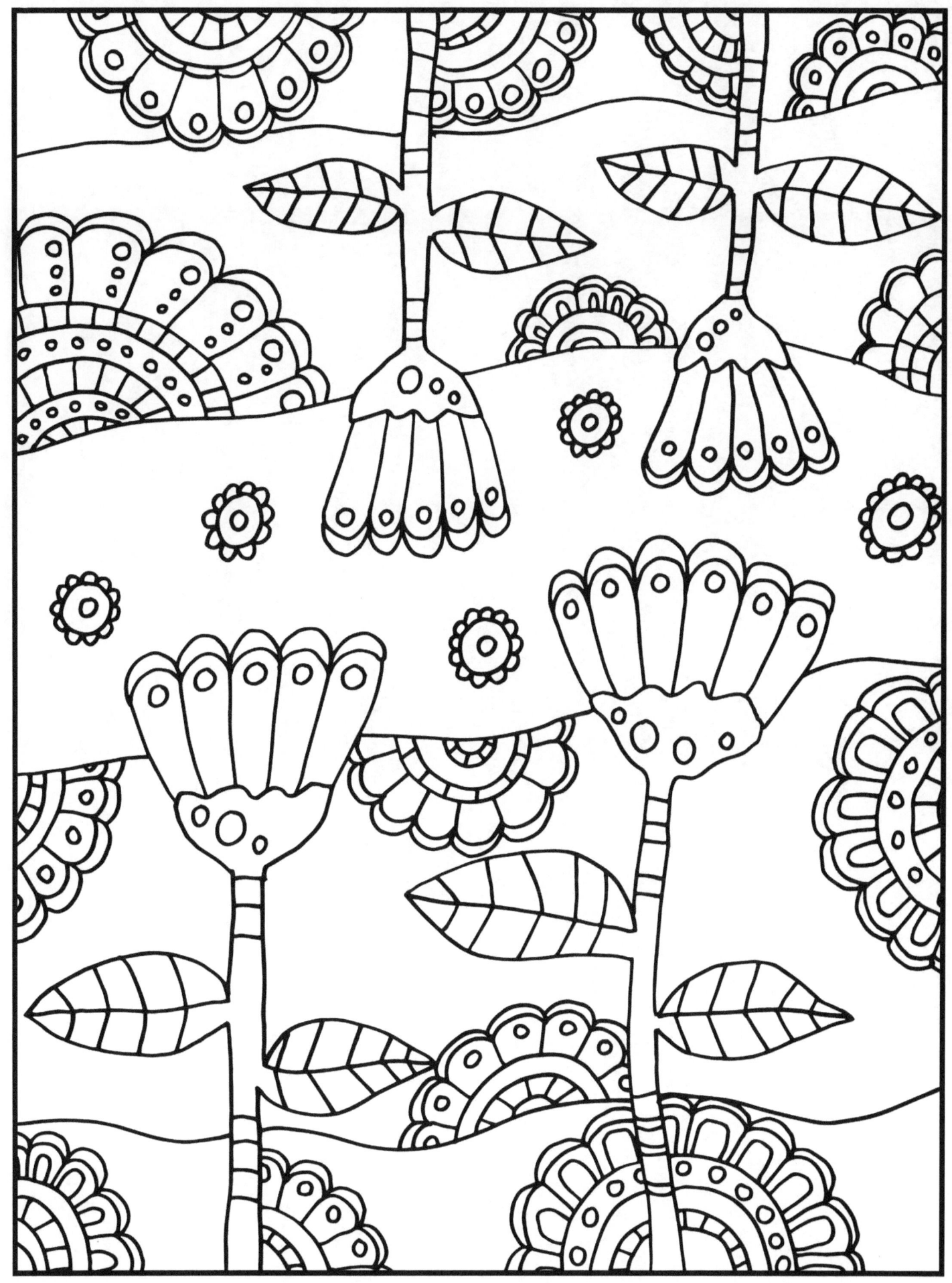

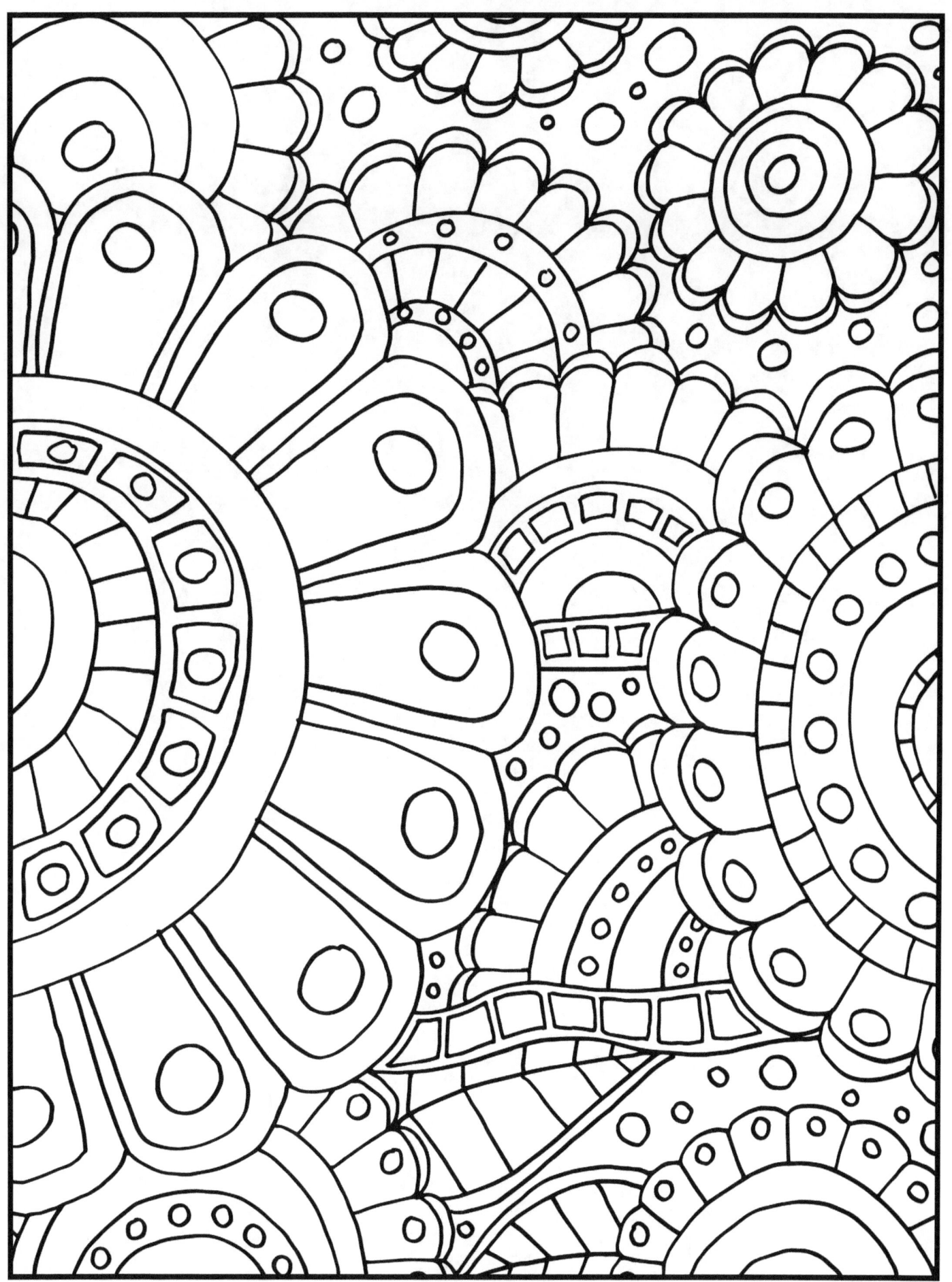

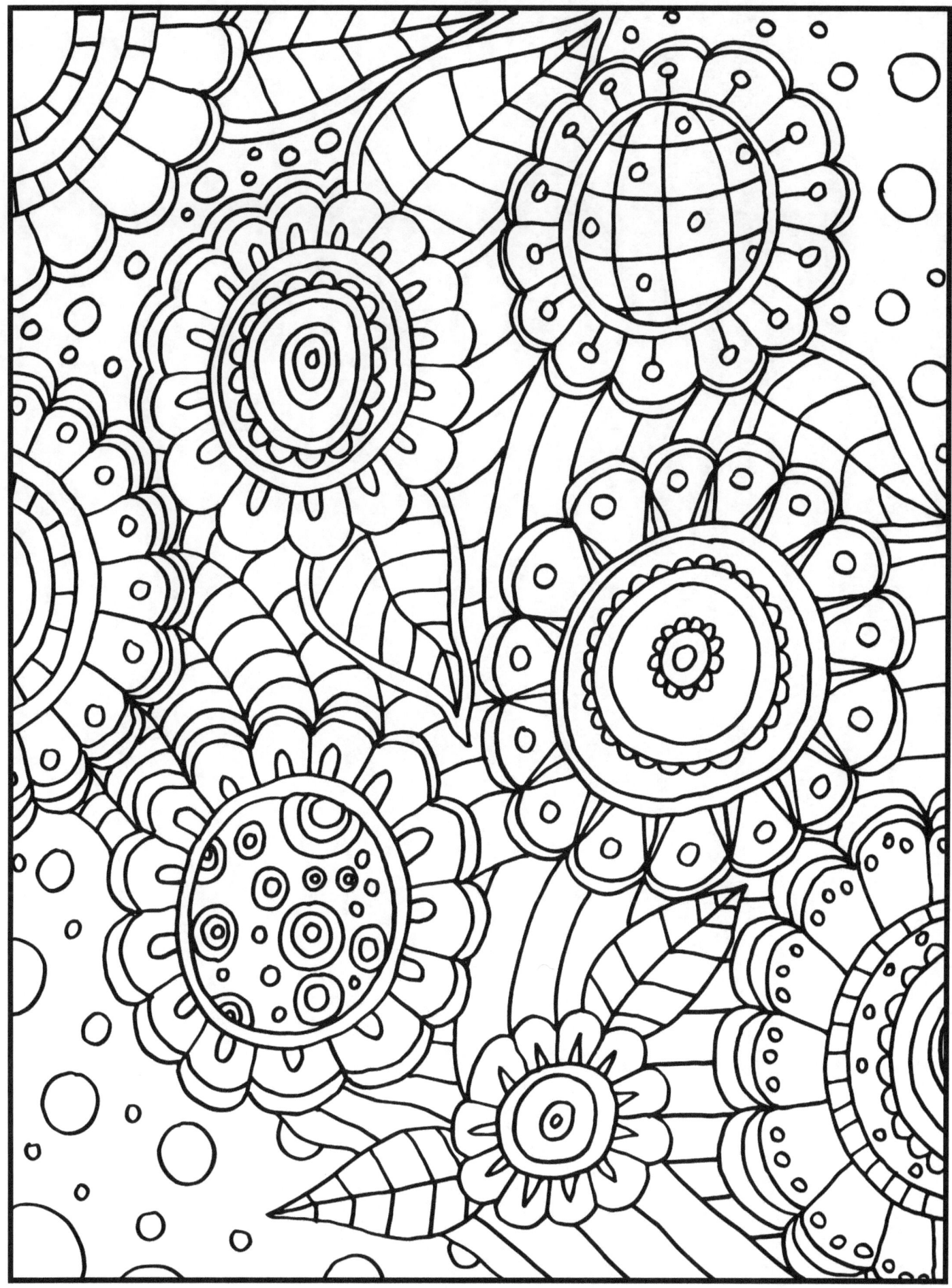

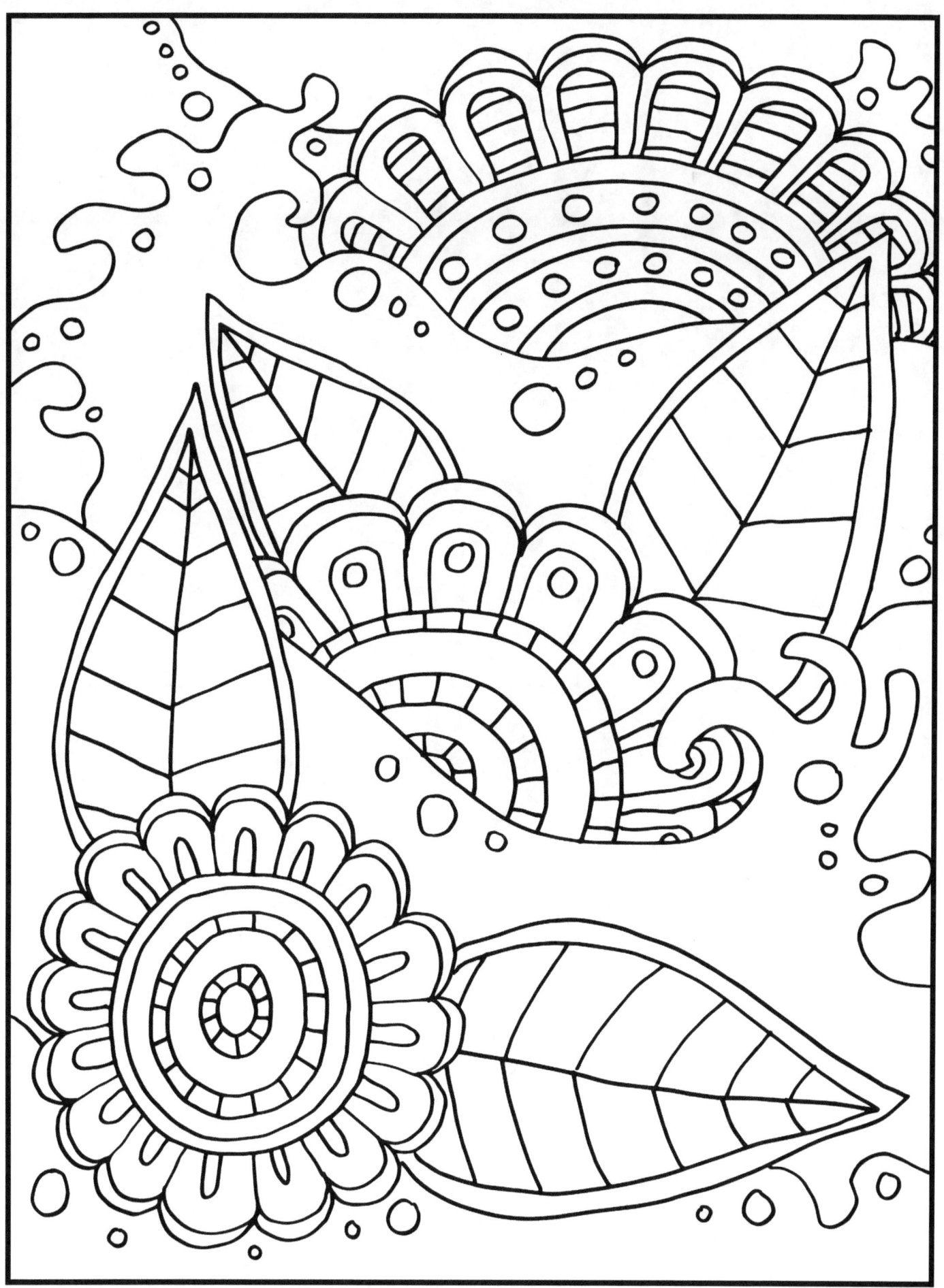

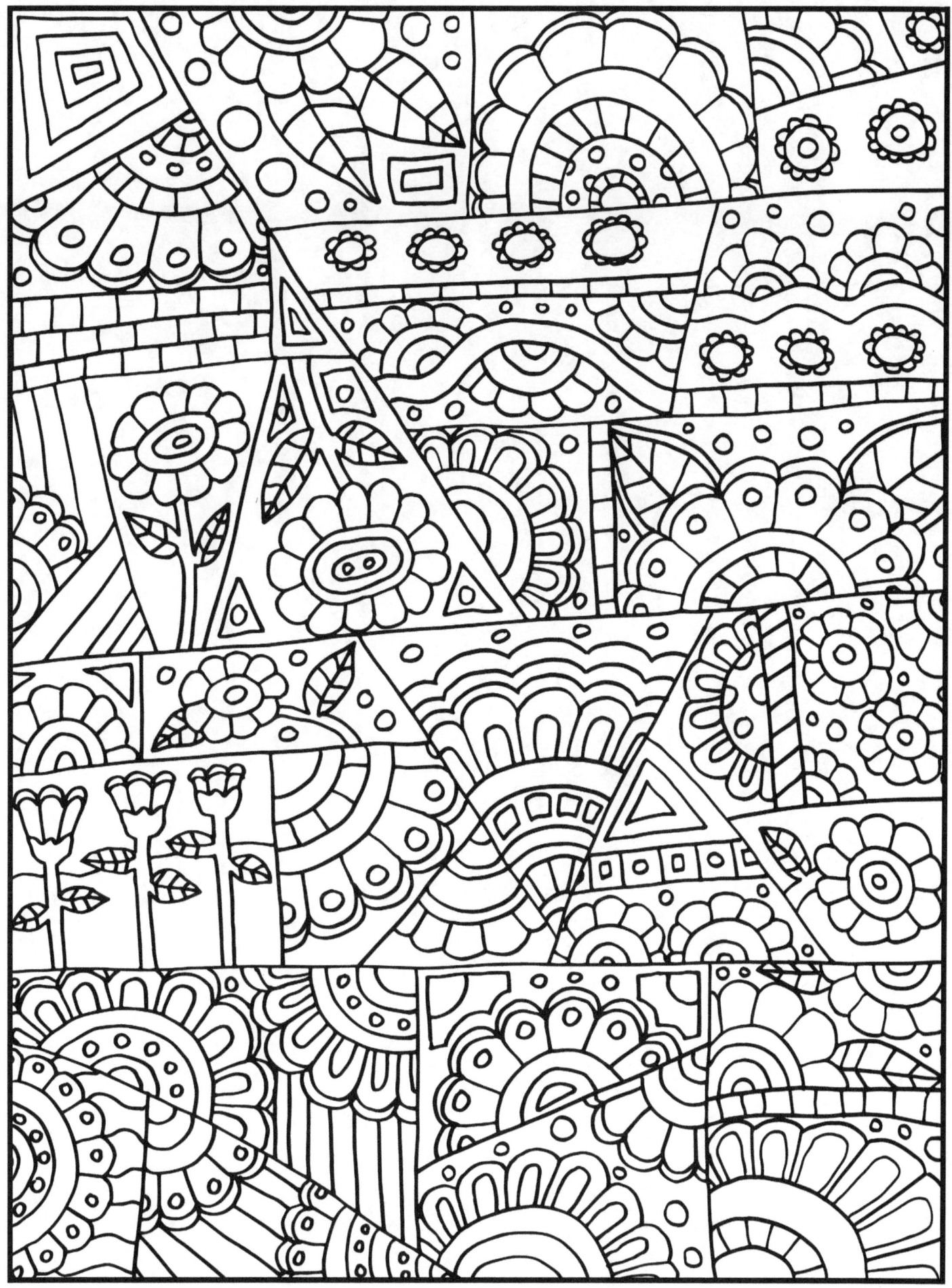

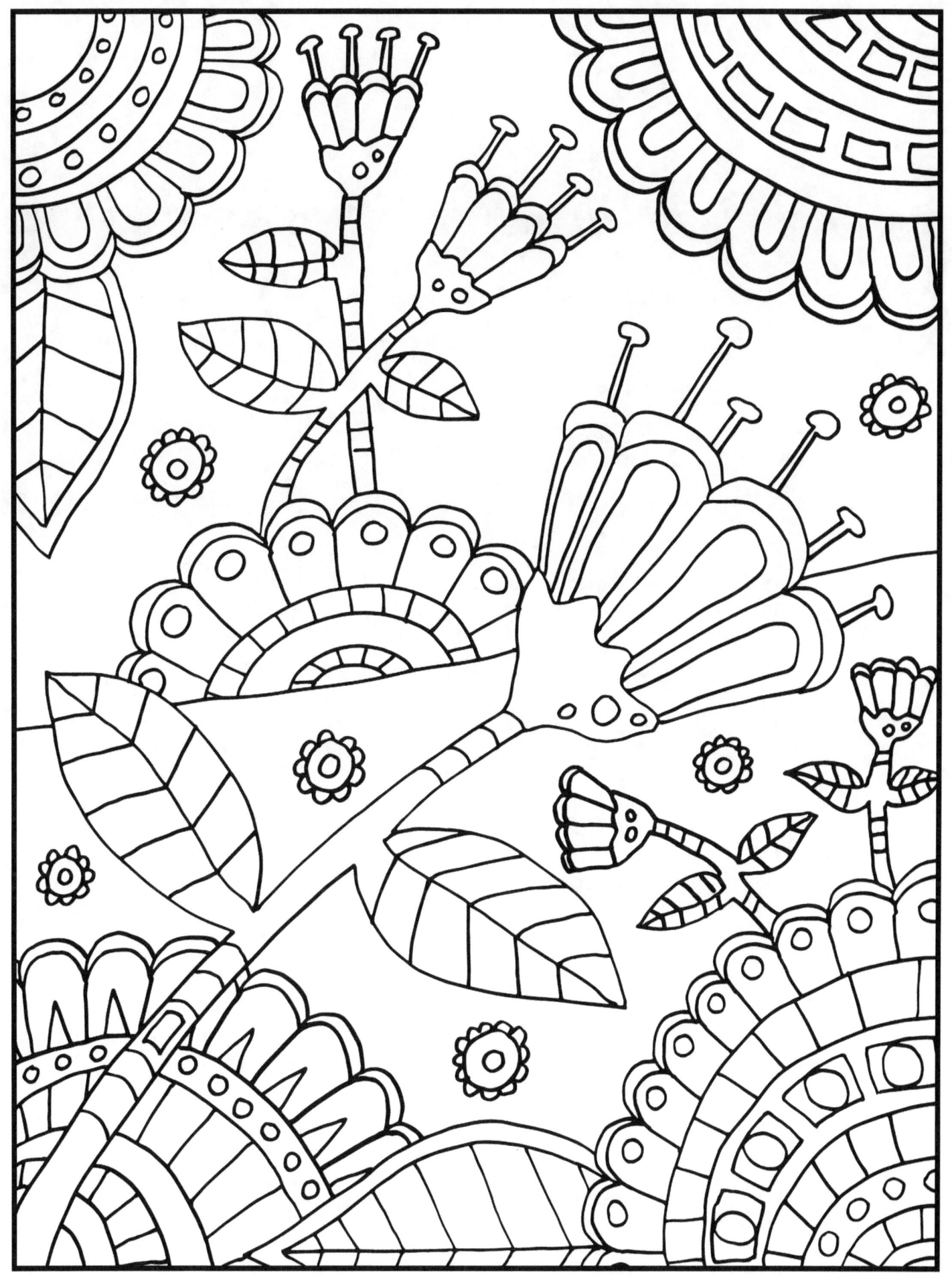

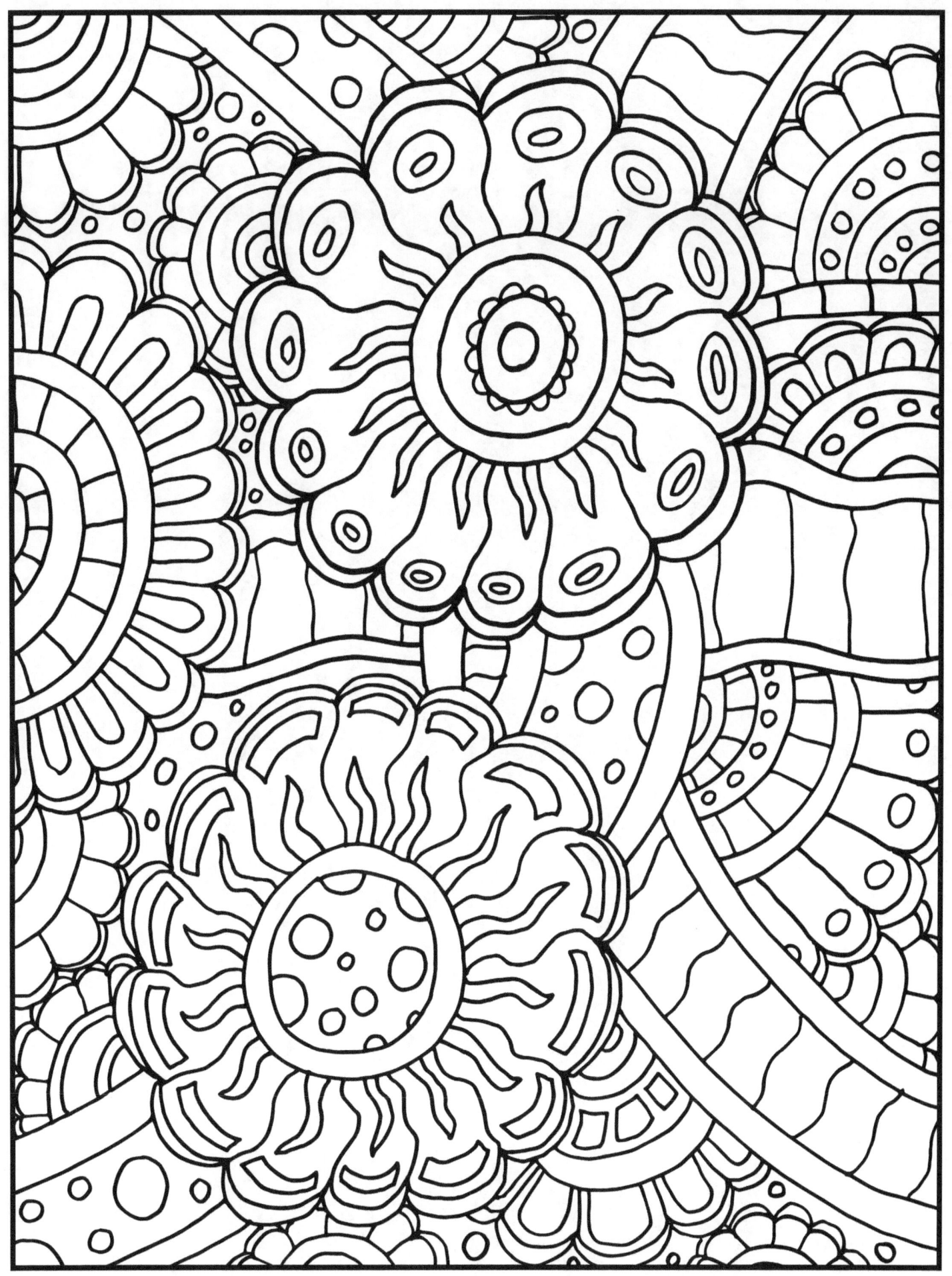

Also Available by Kimberly Garvey

- **Strange Designs** - An adult coloring book for everyone.
- **Strange Little Designs** - A mini/travel adult coloring book.
- **Simple Designs** - An adult coloring book with easier pages.
- **Simple Designs II** - An adult coloring book with easier pages.
- **Simple Little Designs** - A mini/travel sized book w/easier pages.
- **Magical Daydreams** - An adult coloring book for everyone.
- **It's Complicated** - A challenging, more detailed book for the daring colorists.
- **The Fox Book** - A foxy coloring book for everyone.
- **SUPER Simple Designs -** SUPER easy adult coloring
- **Playful Adventures** - An adult coloring book for everyone.
- **Random Designs** - Designs of various difficulty levels.
- **Alien Flowers From Another Dimension** - An adult coloring book for everyone.
- **I Love Hearts** - Heart themed coloring book for all.

KIMBERLYGARVEY.COM

KIMBERLYGARVEY.COM

PROTECTION SHEET

Place this page between coloring pages when using markers to prevent bleed-through.

KIMBERLYGARVEY.COM

KIMBERLYGARVEY.COM

www.ingramcontent.com/pod-product-compliance
Lightning Source LLC
Chambersburg PA
CBHW080721190526
45169CB00006B/2469